SOFA
NEW YORK
SCULPTURE OBJECTS
& FUNCTIONAL ART

**The Seventh Annual International Exposition
of Sculpture Objects & Functional Art**

June 3-June 6

Seventh Regiment Armory
Park Avenue & 67th Street

A project of Expressions of Culture-NY, Inc.

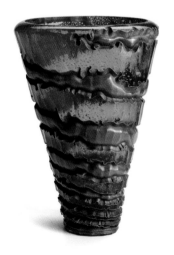

Michael Glancy
Converging Continuum, 2003
deeply engraved (radiation cut) blown
glass with gold foil inclusions and corosso
surface treatment, copper
13 x 9 x 6
represented by Barry Friedman Ltd.

All dimensions in the catalog
are in inches (h x w x d)
unless otherwise noted

Library of Congress – in Publication Data

SOFA NEW YORK 2004
The Seventh Annual International
Exposition of Sculpture
Objects & Functional Art

ISBN 0971371423
2004102027

Published in 2004 by Expressions of Culture-NY, Inc., Chicago, Illinois

Graphic Design by Design-360° Incorporated, Chicago, Illinois
Printed by Pressroom Printer & Designer, Hong Kong

SOFA
NEW YORK
SCULPTURE OBJECTS
& FUNCTIONAL ART

Expressions of Culture-NY, Inc.
4401 North Ravenswood, Suite 301
Chicago, IL 60640
voice 773.506.8860
fax 773.506.8892
sofaexpo.com

Mark Lyman, president

Anne Meszko

Julie Oimoen

Kate Jordan

Jennifer Haybach

Greg Worthington

Barbara Smythe-Jones

Therese Donnelly

Patrick Seda

Bridget Trost

Conte

SOFA
NEW YORK
SCULPTURE OBJECTS
& FUNCTIONAL ART

Welcome to SOFA NEW YORK 2004! We are delighted to welcome the many fine galleries and dealers representing historical as well as contemporary work, with a broad cross-cultural emphasis—from Western to ethnographic to Asian art. A pluralistic understanding of historical contexts deepens our appreciation of contemporary practice. What unites all these approaches is the remarkable resonance of the fine object, marked by an enduring sensuality and a compelling, intellectual sensibility.

We are delighted that Opening Night will benefit the Museum of Arts & Design for the seventh straight year, and officially kick off the Third Annual Contemporary Decorative Arts Week: *Bringing Art to Life,* June 2-8, a city-wide celebration of New York's vibrant contemporary arts and design scene. Many thanks to Holly Hotchner, Director, Museum of Arts & Design, for her continuing support of SOFA NEW YORK and leadership in our rapidly growing community. Many thanks to Sandra B. Grotta and Jack Lenor Larsen, Co-Chairs of Opening Night, and also Arlene Caplan and Myrna Zuckerman, for their work as Auction Co-Chairs.

Special thanks to Museo Carlo Zauli, Faenza, Italy, and Garth Clark Gallery, New York, for their expert partnership in presenting the SOFA NEW YORK 2004 Special Exhibit, showcasing the art of Carlo Zauli (1926-2002), considered one of the greater ceramics sculptors of the twentieth century, alongside works by other major contemporary European ceramists.

Special thanks to the many collector and museum groups attending SOFA NEW YORK, and to the individuals and organizations who have contributed to the superb Lecture Series.

Despite the fluid cultural, material and information exchange in today's world, we hope you will take some time to enjoy the strength of form, quality of design, and superb craftsmanship, that are distinctive hallmarks of the artworks at SOFA NEW YORK.

Mark Lyman, President, Expressions of Culture, Inc.

Anne Meszko, Director of Advertising and Educational Programming

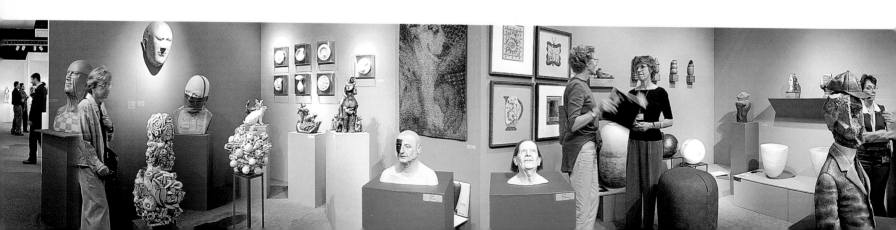

Expressions of Culture, Inc. would like to thank the following individuals and organizations:

Participating galleries, artists, speakers and organizations

Jane Adlin

Ray Ambriano

Aaron Anderson

Art Jewelry Forum

The Bard Graduate Center for Studies in the Decorative Arts, Design & Culture

David Barnes

Jennifer Blum

Kirk Bravender

John Bruno

Desiree Bucks

Arlene Caplan

Julian Chu

Citadel Security Agency

Garth Clark

Keith Couser

Design-360°

Mark Del Vecchio

Floyd Dillman

Pete Douglas

Anne Dowhie

Lenny Dowhie

Jeff Drabant

Empire Safe Company

The Environments Group

D. Scott Evans

Matthew Fiorello

Don Friedlich

Friends of Contemporary Ceramics

Anthony Furino

Orin Goodman

Sandy & Lou Grotta

John Hamilton

Adam & Paula Haybach

Heckler Electric Company

Scott Hodes

Holly Hotchner

Scott Jacobson

Howard Jones

Patrick Keefe

John Keene

Jessica Klein

Ryan Kouris

Jane Kozlow

Lake County Press

Stephanie Lang

Jack Lenor Larsen

Levin & Associates

David Ling

Ellie Lyman

Nate Lyman

Jeanne Malkin

David McFadden

Meadows Wye Cardinal

Desmond Moneypenny

Marjorie Mortensen

Museum of Arts & Design

Larry Mushinske

Mira Nakashima

Ann Nathan

Robert Panarella

Rob Poleretzky

Bonnie Poon

Pressroom Printer & Designer

Daniel Raeburn

Phoebe Resnick

Bruce Robbins

Christina Root-Worthington

Rylander

Judith Sander

Jennifer Scanlan

Linda Schlenger

The Seventh Regiment Armory

Monique Snyder

Society of North American Goldsmiths

Scott Swenson & Staff

TASTE

Barbara Tober

Israel Vines

Larry Vodak

Daniel Webster

Don Zanone

Myrna Zuckerman

photo: David Barnes

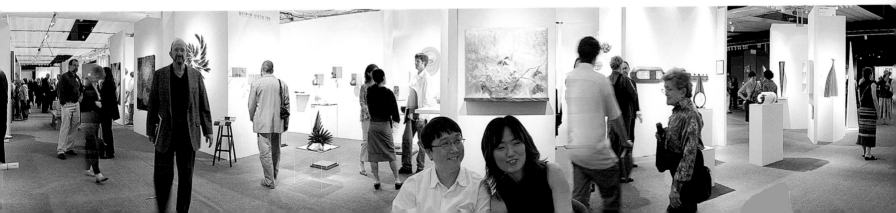

On behalf of the entire Board of Governors and staff of the Museum of Arts & Design, welcome to the Seventh Annual International Exposition of Sculpture Objects & Functional Art—SOFA NEW YORK 2004—at New York's Seventh Regiment Armory. This year, over 50 prestigious international dealers present contemporary works of art by more than one thousand of the world's finest artists. Since its inception, we have been honored to be part of SOFA NEW YORK and to join with Expressions of Culture, Inc., its founder, in an ongoing celebration of creativity in contemporary craft, art, and design.

We are especially proud to host SOFA NEW YORK's Opening Night Gala Benefit Preview, which has become a hallmark of New York's spring benefit season and provides important support each year for our exhibitions and educational programs. And, we are very pleased that this year, by proclamation of The Honorable Michael R. Bloomberg, Mayor of the City of New York, we welcome back Contemporary Decorative Arts Week: Bringing Art To Life, a week-long citywide showcase of New York's vibrant and growing arts and design world.

Right now, we are in the midst of plans for our new home at Two Columbus Circle. Brad Cloepfil of Allied Works Architecture, our talented architect—who has just completed a new building for St. Louis' Contemporary Art Museum—has translated our mission to emphasize the value of materials in the contemporary arts into a brilliant design that truly opens up the building to New York's residents and visitors. This will be the fifth multi-use cultural facility we have developed in our nearly fifty-year history; it is a testament to the great interest in our field that we have once again outgrown our current space. The model for the building is on view this week at the front of the Armory—we hope you will stop by to learn more about the many amenities we will be able to offer you in our new home, and to hear about our Campaign for the Museum of Arts & Design at Two Columbus Circle. We welcome your support for this project as we create a leadership museum for our field and for the ever-changing world of craft, art, and design.

One of the great advantages we will have at Two Columbus Circle will be our ability to display for the first time, in dedicated galleries, our renowned permanent collection. We are currently in the process of building on the foundation of that collection, and are fortunate to have been approached by a number of very generous individuals who are considering donating their entire collections to us, so that visitors to the new MAD will be able to see the very finest in contemporary craft, art, and design.

This spring, in our current home at 40 West 53rd Street, we underscore our commitment to artists and our mission to create landmark touring exhibitions featuring the work of legendary figures in our field by presenting two major shows. The first of these, Jack Lenor Larsen: Creator and Collector, highlights the role of the designer in the contemporary arts, juxtaposes Larsen's fifty most important textiles with the art he has collected over the past half-century, and pays homage to the man often called "the dean of American textile design." We are very proud to have organized this exhibition in collaboration with the Liliane and David M. Stewart Program for Modern Design in Montreal, and to have received as a donation from Cowtan & Tout a number of significant archival textiles created by Larsen during his career.

Paul Stankard: A Floating World—also organized by MAD—is our second major spring exhibition. A Floating World is the first exhibition to review four decades of the extraordinary work of the undisputed master of lampworked sculptural glass. Approximately 75 pieces of "Botanicals" and paperweights spanning Stankard's 40-year career—including recent, never before exhibited work—are presented in this intimate, delightful show. I hope you will visit MAD, and these wonderful exhibitions, while you are in town for SOFA NEW YORK 2004, and that you will peruse the shows' accompanying catalogues in The Store at MAD.

This is truly a landmark year for MAD, and for craft, art, and design. As we celebrate our accomplishments together, we would like to salute Mark Lyman and Anne Meszko for their devotion to our museum and to our mission, and for their phenomenal

contributions to our field. Thanks to Mark and Anne, SOFA NEW YORK and its sister show, SOFA CHICAGO, have become the gold standard throughout the world for contemporary arts and design expositions. We would also like to thank Sandra B. Grotta and Jack Lenor Larsen, Co-Chairs of our Opening Night Gala Benefit Preview, for their tireless efforts on behalf of MAD and of our field. Special thanks also go to Arlene Caplan and Myrna Zuckerman, for their work as Auction Co-Chairs; to our SOFA NEW YORK 2004 Vice Chairs; and especially to Barbara Tober, Chairman of our Board of Governors, whose dedication to our mission is unequalled. Finally, I would like to extend special thanks to our entire Board of Governors, whose wise counsel and committed leadership sustain our efforts every day.

On behalf of the Board of Governors and the entire staff of the Museum of Arts & Design, I look forward to welcoming you to the Museum this week and seeing you around the City, enjoying all of the wonderful events that are part of Contemporary Decorative Arts Week and New York City's vibrant craft, art, and design scene.

Holly Hotchner

Holly Hotchner
Director

ectures

Lecture Series

sponsored by SOFA NEW YORK 2004

SOFA NEW YORK Lecture Series explores the history and aesthetics behind the art, the artists, processes and materials. Lectures are in the Tiffany Room and are free to SOFA attendees unless noted otherwise.

Thursday
June 3

1:00 pm – 2:00 pm
Creator and Collector:
A Conversation with Jack Lenor Larsen
Jack Lenor Larsen: Creator and Collector, a major exhibition on view at the Museum of Arts & Design through August 29, looks at the worlds of art, craft, and design through the designer's eye. Highlights are Larsen's influential fabric designs created over five decades, and a selection of rare objects from Larsen's personal collection. **David McFadden**, co-curator of the exhibition, will engage **Jack Larsen** in an informal conversation about his career as weaver, designer, world traveler, and collector.

2:00 pm – 3:00 pm
Searching for the Harmonic Chord
Artist **Michael Glancy** shares insights into his creative environments, with an intimate look at the studios, interests and experiences forming the intellectual foundation of this artist's work in glass and metal, in a conversation with writer and curator **William Warmus**.

Michael Glancy is Adjunct Faculty, Jewelry and Metalsmithing Department, School of Fine Arts, Rhode Island School of Design, since 1982. He is represented at SOFA by Barry Friedman Ltd., New York City.

3:00 pm – 4:30 pm
The Nakashima Legacy: Continuity and Change

George Nakashima: The Aesthetics of Design
A close look at Nakashima's innovative furniture designs. A consistent philosophic and aesthetic approach will be shown to inform his work from conception through to final product. **Dr. Robert Aibel**, owner/director, Moderne Gallery, Philadelphia

Mira Nakashima and the Studio, 1990-2000
A slide presentation of Studio production since 1990, including the Krosnick house in Princeton, the reading room for the James A. Michener Museum in Doylestown, the Gabellini projects, and David Hovey installations; illustrating how the work evolves from tree to client by way of pencil drawings and final cutting in the workshop – an inherently unpredictable process. Since her father's death in 1990, **Mira Nakashima** has been the creative director and designer of the Nakashima studio in

(continued)
New Hope, PA, where she produces her father's classic furniture designs as well as her own work.

Mira Nakashima attended Harvard University and received a master's degree in architecture from Waseda University in Tokyo. She worked for many years with her father, George Nakashima, as a colleague and designer in his workshop. She is represented at SOFA by Moderne Gallery.

4:30 pm – 5:30 pm
What Postmodernism is Not!
Postmodernism is a big sprawling field that is deliberately difficult to define. **Mark Del Vecchio** will show cutting edges in postmodern ceramic art today and explain what postmodernism is "NOT".

Mark Del Vecchio is director of Garth Clark Gallery, New York City.

Friday
June 4

noon – 1:00 pm
Searching for the Present in the Past
A resident of the former East Germany, **Vera Siemund** explains what jewelry and making jewelry mean to her, and the many different forms that inspiration can take. Presented by Art Jewelry Forum in conjunction with SOFA.

Vera Siemund studied jewelry with Dorothea Prühl at Burg Giebichenstein in Halle, Germany. She is represented at SOFA by Jewelers' Werk Galerie, Washington DC.

1:00 pm – 2:00 pm
Whitman, Joyce, Sex, Death and God
Paul Stankard illustrates the evolution of his glass botanicals into personal symbols, influenced by poetry; a 40 year journey culminating in his retrospective at The Museum of Arts and Design in NYC, which opens May 28.

Paul Stankard is a studio artist, represented at SOFA by Marx-Saunders Gallery, Ltd., Chicago.

2:00 pm – 3:00 pm
MADOLA's Work
Mª Angels Domingo Laplana (**MADOLA**), of Barcelona talks about the development of her ceramic sculpture and its influences: primitive art, the ancient cultures, Picasso, Miro, Voulkos, Tapies and architecture of all époques; and the realization of large scale commissions in Spain, England and other countries.

MADOLA holds a degree in sculpture and doctorate courses on urban space from the College in Barcelona. She will exhibit a body of new work at SOFA with Galerie b15 of Munich.

3:00 pm – 4:00 pm
Spatial Concepts
Sculptor **John Mason** will speak about the history of his early works, from the late 1950's and 60's, and how those concepts transcend through the succeeding decades into his most recent work.

John Mason, with Peter Voulkos, led the 'Revolution in Clay' in the 1950's, changing the course of contemporary ceramics from a functional medium into a vigorously expressive one. He is represented at SOFA by Franklin Parrasch Gallery, New York City.

5:45 pm – 6:45 pm
My Life as a Journey
Kiwon Wang's traditional Korean upbringing is evident in her jewelry's ongoing dialog between east and west, tradition and modernity. She will present a brief history of Korean jewelry and envision its developmental path; and speak about her personal experience as a Korean jeweler who works and resides permanently in America.

Kiwon Wang received a master's degree from the Rhode Island School of design. She is curator of Fresh Air from Korea, a traveling exhibit of Korean metalwork on view at Snyderman-Works Galleries, Philadelphia, where she is exhibiting.

Saturday
June 5

10:30 am – noon
British Craft Now
Contemporary British craft has flourished since the end of the Second World War, spurred in large part by two of Britain's finest and most prolific studio potters, Lucie Rie (1902-1955) and Hans Coper (1920-1981). Together they sparked new interest in making contemporary ceramics and influenced subsequent generations of artists. British craft expanded to include art made from glass, fiber, and metal, and young designers began to produce one-of-a-kind or limited-series avant-garde furniture, jewelry, and lighting for the art market. Art historian **Jane Adlin** will explore the vitality of Britain's craft tradition in an introductory lecture, 10:30 am – 11 am, followed by a tour of selected objects on view at SOFA, 11am – noon.

Jane Adlin is assistant curator in the Department of Modern Art at The Metropolitan Museum of Art where she has contributed to the organization of exhibitions including Significant Objects from the Modern Design Collection, Beyond Textiles: Contemporary Art in Fiber, and Art Deco Paris (forthcoming).

This program has been organized by The Bard Graduate Center for Studies in the Decorative Arts, Design, and Culture in conjunction with SOFA to complement Bard's exhibition *The Devonshire Inheritance: Five Centuries of Collective at Chatsworth.* Tickets necessary.

1:00 pm – 2:00 pm
Three Master European Silversmiths: Historic Perspective, Contemporary Practice
Silversmiths **David Huycke**, Belgium, **Allan Scharff** and **Claus Bjerring**, Denmark, elaborate on what they believe is essential in their contemporary expression of form with a historic perspective, as seen from a European angle.

Allan Scharff and Claus Bjerring have designed collections for George Jensen. The silversmiths are represented at SOFA by Galerie Tactus, Copenhagen.

2:30 pm – 3:30 pm
Working Toward the Center
Lush foliate imagery and richly carved forms combine in **Sharon Church's** jewelry to create metaphors about life and longing. The artist will discuss her mid-life search for increasingly poignant imagery through iconic form. Presented by the Society of North American Goldsmiths in conjunction with SOFA.

Sharon Church is a professor in the College of Art and Design of The University of the Arts, Philadelphia. She received her MFA from the School for American Craftsmen, Rochester Institute of Technology and is represented at SOFA by Helen Drutt: Philadelphia.

SOFA 2004

Essays

Jack Lenor Larsen:
A Designer's Vision,
A Collector's Passion

David Revere McFadden

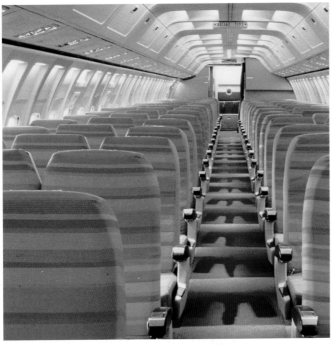

B.

For over half a century, Jack Lenor Larsen has held a preeminent position in this country as a textile designer. Larsen's designs have been the subject of exhibitions in this country and abroad, and have been collected by museums with notable collections of decorative arts, design, and textiles. Using a diverse array of natural and synthetic fibers, and an equally impressive body of weaving structures and techniques, Larsen has effectively merged the sensibility of the studio artist-weaver and the rational practicality of the industrial designer. Larsen's designs are inspired by his innate sense of color and texture resulting from his lifelong love of nature, drawing upon a wide-ranging and personal library of design ideas that reflect this interest. At the same time, Larsen is a dedicated collector of decorative arts and handcraft from around the world. Larsen's LongHouse Reserve, a museum housing his personal collections, a land-scaped botanical and sculpture garden, and performing arts center mirror his personal pleasures and professional passions.

Weaver, designer, collector, architect, gardener, author, traveler, entrepreneur: these roles are explored in *Jack Lenor Larsen: Collector and Creator,* an exhibition organized by the Museum of Arts & Design in collaboration with The David and Liliane Stewart Program in Modern Design in Montreal. Following its New York showing, *Jack Lenor Larsen: Collector and Creator* will travel to selected museums in this country and abroad. Featuring over fifty of Larsen's fabric designs from the past fifty years, and seventy-five objects—ceramics, glass, fiber, wood, metal—collected by Larsen over his lifetime, the exhibition offers the viewer a unique opportunity to see the worlds of art, design, and craft through the designer's eye. The exhibition is organized thematically rather than chronologically, mixing works from the collection with fabric designs to reveal the visual affinities that exist between them. The issues explored in *Jack Lenor Larsen: Collector and Creator* range from the designer's continuing interest in the effects of light and translucency in fabric design and the decorative arts, the powerful potential of pattern and color, the tactile subtleties of surface and texture, and the timeless qualities of form and structure that serve as the foundation for all design. In addition, the exhibition reviews some of the most important commissions awarded Larsen, from his early designs for the landmark Lever House in

New York City, to the exuberant colors that distinguished the interiors he created for Braniff Airlines passenger airplanes [B]. Early experimental works such as a grass root and linen weaving made by Larsen in the 1950s to his most recent designs for wall coverings and environmentally friendly, reflective solar window fabrics, show the range of Larsen's creativity, and the continual evolution of his designs resulting from his perpetual curiosity and love of experimentation.

Larsen received his MFA from the Cranbrook Academy of Art with fiber as his medium, but he did not study design in any formal sense. To this day, he refers to himself as a "weaver" and a "servant to architecture,"[1] having been enamored of architecture and building from his early childhood. Indeed, he views this subject as fundamental to his developing eye as a designer and his skill as a weaver. Through his examination of architecture he gained a deep understanding of the importance of controlling natural light in any structure, using the maximum to illuminate interiors and open them to the environment, or the minimum to allow the occupants privacy and assure their comfort. The "Larsen Look" was created, to a great extent, by the designer's innovative experiments with sheer or reflective fabrics utilizing an understated palette of natural and neutral fibers: they were a perfect complement to the spare and restrained simplicity of modern architecture. As a practicing weaver and modernist designer, Larsen conducted his trend-setting experiments with materials and techniques to produce surfaces and textures that animated interiors and furnishings with tactile appeal. As a colorist and avid student of world cultures, he used hue and pattern to seduce and delight the viewer. Through color he expressed another facet of his vision, looking far afield to distant and exotic parts of the world and periods of time, to the history of art, and to his beloved gardens. Color and pattern became, for Larsen, a second language.

C.

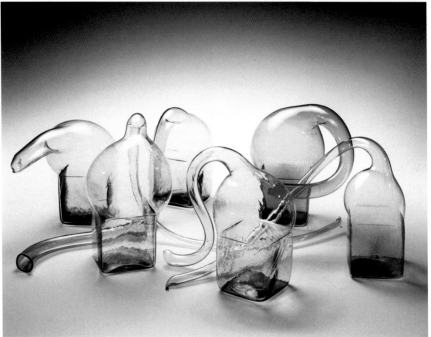

D.

Larsen describes his creative trajectory as bringing together "the aesthetics of architecture, the color of painting, and the techniques of weaving." These interests complemented and contrasted with his perennial experiments with the subtleties of surface and texture. Larsen expresses his love of architecture and sculpture in his passionate interest in the forms and structures of past and present. His global wanderings, which have taken him to every continent and most countries within them, have given him unique opportunities to study architecture and design in their original contexts.

If form and structure are the core of his overall design approach, they have also shaped his eye as a collector. For Larsen the bones of any design are as meaningful as the skin, whether they be in a building, a ceramic vessel, or a piece of wooden furniture. He has always been attracted to the strength and discipline of pure geometric forms. In sculptural objects, however, his predilection has, more often than not, veered toward more organic and sensuous forms, as seen in the curvilinear basketry he has chosen, in the spirited natural shapes of ancient and prehistoric pottery, and in the elegant and curvaceous profiles of hand-raised silver.

"Weaving is very similar to architecture," Larsen has said, "in that both build within limitations with a high interest in materials and similar dependence on shade and shadow."[2]

The designer recognized that the greatest challenge of our time would be designing fabrics for the new glass-walled buildings—towers and residences: "Traditional draperies had primarily shut out light and afforded privacy. But now the houses and buildings that people were commissioning architects to design usually had a view—if not a city skyline then at least a private garden. We had to respond to these changes and new needs in an innovative and attractive way through new types of fabrics and new materials. My future relationship with architecture was established."

Larsen's early and well-known *Bahia Blind* [C], employs the "skeleton" of a traditional Austrian drapery to choreograph the passage of light as a series of graceful curves that move with a breeze. The design is by no means a simple quotation

C.
Jack Lenor Larsen
Bahia Blind, *1959*
linen, silk, rayon; woven fabric
Collection Cowtan & Tout
photo: Richard Goodbody, 2003

D.
Dale Chihuly
Spouted vessels (six) c.1968
mold-blown glass
various sizes
Collection Jack Lenor Larsen
photo: Leonard Nones

from the antique, however, but one that reiterates the graceful form with modernist simplicity. Larsen has always believed that history was an unending source of inspiration in his designs, and often urges other designers to study yesteryear's achievements: "I am amazed how many younger people I'm seeing now who don't know historic fabrics or ethnic fabrics or have never looked at Peruvian weaving or didn't know that ikat was an old technique. I wish they would look at good old things, not necessarily even in fiber."[3]

The designer has always surrounded himself with objects that exploit different qualities of light, through transparency, translucency, and reflectivity. Larsen was one of the early patrons of a young, talented, and ambitious artist who chose the relatively new field of studio glass as his forte, Dale Chihuly. Chihuly has established his international profile in the field of art glass through his virtuoso handling of the medium, his uninhibited use of color, and his dramatic and memorable installations. Larsen recognized the potential of this

emerging star, who began his career as a weaver and came to Larsen's attention as a result of his use of glass strips interwoven with fiber, and his creation of nearly transparent or smoky translucent glass in organic forms that evoke the world of undersea life.

The pattern *Leaves of Grass* [G], designed by Don Wight and produced by the Larsen Studio, evokes the rough texture created when the hot wax used in this dyeing technique cracks when cooled, permitting skeins of brilliant color to saturate the fabric. The Larsen collections of fine and decorative arts reiterate the theme of surface and texture in memorable and sometimes surprising ways.

Basketry, which produces what Larsen calls "tactile vessels," has always been a favored field for his collecting; throughout his life he has never passed up the opportunity to acquire baskets that document a unique place or time, which highlight unusual structure, color, or texture, and which, through their beauty alone, epitomize this humble

and often overlooked field of creativity. Larsen has credited basketry as the progenitor of weaving: "In most cultures, weaving, as we know it today, emerged from basketry—as did pottery and plaiting." Basket-making depends on the intimate relationship of hand and material. The tactility of the process nearly always remains in the finished work, something that can best be appreciated through touch. Works by many of America's premier artists in the medium have found a home in the Larsen collections.

In Larsen's designs and in his collections, eye and hand work in sympathy, each supporting and enriching the other. In textiles—in fact in almost all art works—surface and texture can only be fully, completely experienced with both eyes and hands, and herein lies their alluring beauty. Larsen recognized the universal appreciation of handwork at the outset of his career, and has never neglected the potential of surfaces and textures to bring meaning and pleasure to our lives.

E.
Chunghie Choo
Lily Vase, *1980*
copper, silver plated;
electroformed
23 x 3.5 x 4
Collection Jack Lenor Larsen
photo: Richard Goodbody

F.
John McQueen
Basket, *c.1977*
wood; splayed, interlaced
31 x 10 x 10
Collection Jack Lenor Larsen
photo: Leonard Nones, 2003

G.
Don Wight for Larsen Studio
Leaves of Grass, *1971*
cotton; batik
Collection Cowtan & Tout
photo: Richard Goodbody, 2003

E. F. G.

H.

I.

Color and pattern explode in Larsen's geometric, abstract, and figural designs, following his restless and relentless eye. From the earliest years of his career as a designer to the present day, he returns again and again to patterns that embody a moment in time and taste, such as those seen *Happiness* [H] a hand-screened print from the Kublai Kahn collection, one based on Asian patterns. It is not surprising that Asian designs have appealed so much to Larsen, given the love of Chinese, Japanese, Korean, and other Asian arts that developed in his childhood. "When I was in school and visited the Seattle Art Museum," he recalls, "they had wonderful Asian collections that included fabulous fabrics. I made photographs, especially of the beautiful Ming dynasty robes." Ming wave patterns and cloud scrolls reverberate in the pattern of *Happiness,* while the cloth of mohair, rayon, and cotton gives the colors their depth and richness.

Perhaps the most mouthwatering pattern and colors created at the Larsen studio appear in *Primavera* [A] with its glorious palette and scattered, jewel-like floral motifs, which summon up the Byzantine splendor of a painting by Gustav Klimt. When introduced in the late 1960s, Larsen's printed velvets were so unexpected that they were not immediately popular; it was only when clients and designers realized their enormous potential as upholstery fabrics that sales skyrocketed.

Larsen sums up his deeply held beliefs about color and pattern: "For a number of years architects and apparel designers have ignored patterned fabrics on the premise that there is pattern enough in our congested and active lives. They have also suggested that ornament is inconsistent with a democratic society... But ornament seems to have existed everywhere in time and place, and in every kind of society. For that matter, much fabric *is* ornament, and should have the occasional opportunity to be rich or sensuous."

Larsen's respect for form and structure is the logical outgrowth of his background in architecture: "I wasn't taught fabric design. I was taught architectural design." Form and structure are revealed by the fabrication techniques Larsen selects, making his fabrics sympathetic to the pared down simplicity of modern corporate and domestic interiors. Richard Landis, a brilliant and obsessive weaver inspired by the natural world around him, often used hundreds of different hues of yarn to create his memorable essays in the gradation of color. Larsen deeply admired both the artist and his work, and paid homage to him in the fabric he called *Landis II* [J]. Displayed in complex geometry, its vibrating colors appear to shift constantly as light does over a landscape vista while maintaining the disciplined structure of the weave.

In many of the objects that Larsen has acquired, form, structure, and materials hearken back to nature as the ultimate source of design. Attenuated and eccentric floral forms are suggested by metalsmith Chunghie Choo in *Lily Vase* [F]. The animated organic shape is reminiscent of both exotic flowers and the swirling draperies of the fin-de-siècle dancer Loie Fuller captured in a stop-action image.

Even a cursory glance at the range of Larsen's designs and the diversity of his collections over the decades indicates the multi-level artistic and cultural links that have been keenly perceived by the designer. However, if one single work from his collection can serve as a metaphor for Larsen's vision and philosophy, it would probably be an indigo futon cover of the nineteenth century [I], made by an anonymous artist in Japan from countless scraps of well-used fabric. The humility of the materials and the cover's quotidian function contrast with its visual impact. Patched and repaired over the years, the work has evolved to become an abstract composition in fiber, which the designer sees as "the perfect marriage of materials and technique, of compositional form and visual delight." The object may, in many respects, serve as a metaphor for Jack Lenor Larsen, his career and his designs. The cover fulfills a clear practical purpose, in the same way in which Larsen intends his designs to be completed by their use, and by being seen and touched and enjoyed by human beings. The design of this assembled piece is improvised and unpretentious; to some observers, it may even look accidental or haphazard. Throughout his career, Larsen has embraced the spontaneous

visual effects of irregular textures, evanescent color combinations, and memorable forms, and has translated them into something permanent. The variety of colors achieved through a single dye—in this instance, indigo—is paralleled by the range of expressions that Larsen creates using a single color or a limited palette. When combined with the diversity of colors that Larsen sees in the world around him, the simplest visual statement can be transformed into an elegant poem of pattern, texture, and form. Finally, it is the tactile qualities of this work that draw us to it. Embedded in its fibers are memories of earlier generations, intimate stories of how these scraps of fabric began, who wore them and treasured them. The object is alluring to our eyes and to our hands simultaneously. The hand and the eye of Jack Lenor Larsen are also intrinsic to all of his designs and his collections. If we can learn to see with our hands and feel with our eyes as he does, we can more fully enjoy the creativity of the artist and the collector.

[1] Quoted in Barbara Liebler and Nell Znamierowski, "Interview: Jack Lenor Larsen," *Handwoven*, January/February 1991, p. 18.

[2] David Massello, "Grand Larsen-y," *Art & Antiques,* September 2001, p. 82.

[3] Jack Lenor Larsen, "Fabrics in a New Dimension," *Industrial Design,* vol. 9, no. 12, December 1962, p. 84.

David McFadden is Chief Curator and Vice President for Programs and Collections at the Museum of Arts & Design.

Jack Lenor Larsen: Creator and Collector is on view at the Museum of Arts & Design from May 28 through August 29, 2004. Portions of this essay are excerpted from the exhibition catalogue published by Merrell Publishers, London.

Published in conjunction with the SOFA NEW YORK lecture *Creator and Collector: A Conversation with Jack Lenor Larsen.*

J.

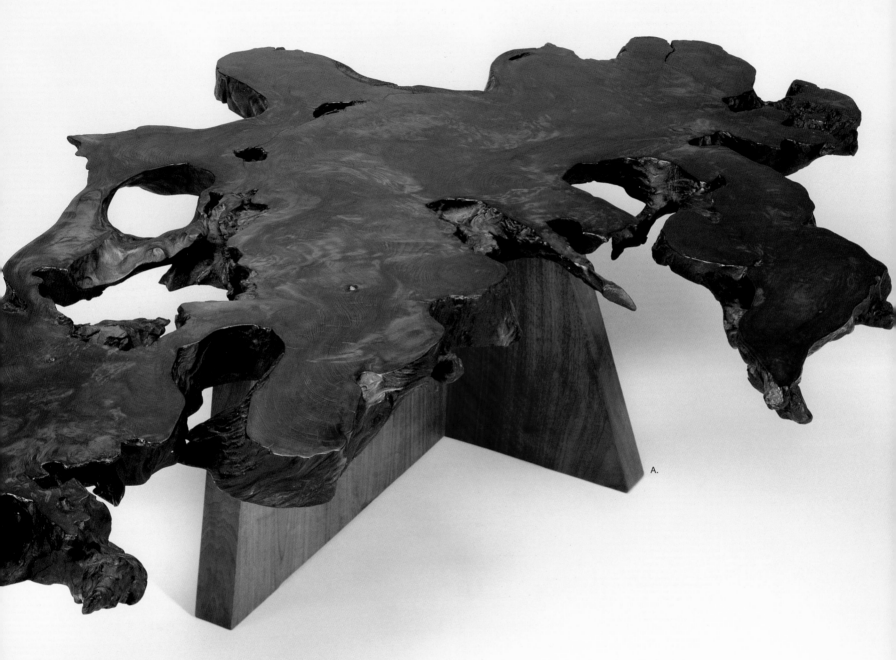

A.

My Father,
George Nakashima

Mira Nakashima

My father, George Nakashima, was born of Samurai lineage in Spokane, Washington, died in New Hope, Pennsylvania in 1990, and prided himself on being "the world's first hippie," a Hindu Catholic and Japanese Shaker Druid. Trained and employed as an architect before he turned to furniture, he was inspired by Frank Lloyd Wright, saying he was grateful to Wright for "showing him what not to do" with his life. Although renowned as a man of peace, he built his business as a one-man battle against modern technology, embracing the principle of hand craftsmanship assisted by power machinery, utilizing natural wood not only as his material but his inspiration.

I have come to believe that George Nakashima was an artisan in the Mingei tradition as defined by philosopher Soetsu Yanagi, founder of the Japanese Living Treasure program in the 1920's, in which the goal of the artisan is to achieve the state of "no mind." Following the Japanese traditions of the Zen and Tea Ceremony masters, the Nakashima aesthetic embodies the ideals of *wabi* and *sabi,* subtle definitions of light and shadow which override decoration and bright colors, while negative spaces create a strong but silent dialogue with the positive and dynamic elements. Whereas in Western tradition, the goal is innovation and an egotistic striving for the creation of "new" forms, the Eastern traditions honor, revere, and indeed appear to imitate by repeating forms until they

become second nature to the artisan. Unlike Western tradition, Eastern traditions value, as Shoji Hamada once said, "the variety of sameness" perceived not as boring repetition but a way to true understanding of the nature of form.

My father, who had attained status as an Eagle Scout, was a pioneer and trail-blazer, the first in this country to call himself a "woodworker" as a non-derogatory term. He cumulatively built his own tradition of design integrated with the woodworking process and with the nature of wood itself, with the result that most of his early designs continue to be made to this very day.

Unique in their time, the outward forms and process have inspired many to imitate and emulate his innovations. He believed that a man's life and work should be integrated, rather than separated, and that work was not just a way to earn a living, but a way to live, a way of being, a karma yoga. At the heart of his creativity lay a very non-Western ideal of monasticism and spirituality germinated in the mountains and forests of the Olympic Peninsula, nurtured and inspired by the magnificently articulated space of the great Cathedral of Chartres, and driven home by his two years' work at the Sri Aurobindo Ashram in Pondicherry, India. This theocentric, rather than egocentric view of the Universe meant being receptive to a higher power, which not only kept his ego in perspective, but opened up new realms of possibility in design, unbounded by previous convention. Techniques from Japanese carpentry, as well as vernacular forms from the Shaker and Windsor traditions were adapted to contemporary life and design, often in unconventional ways, such as the decoratively exposed butterfly and dove-tail joinery which have become our trademarks. The Nakashima tradition speaks of subtle proportion as well as strength, and follows directly in the path of Mies Van der Roe's tenet "less is more." Exposed joinery is used in a decorative manner, but only when it is structurally necessary.

Beyond this, George Nakashima encouraged the forces and forms of Nature itself to speak for themselves. He never molded them into man-made shapes, as most other furniture makers do. This did not mean, however, simply coating a naturally shaped slab of wood with varnish and setting it on legs, like the barrage of Redwood tables that were popular during the 1960's. Nakashima's "free-form" tables are carefully blended with artistically balanced and angled cut edges and bases designed in the same manner as architecture. In our work, great care is taken to use trees harvested in a sustainable manner, trees which have reached maturity and are no longer viable, trees that must be removed to make room for buildings. Some trees have been taken for some purpose inappropriate to their nature, such as those three magnificent 11' long by 60" diameter Bubinga logs destined to be cut into 1"x1" pieces for knife handles that my father rescued. Much of our lumber is acquired through serendipity, such as cancelled orders of exotic lumber like Persian Walnut, or irregularly shaped burls with too many holes for veneer purposes. My father once shocked a reporter by saying that his work was really a lumber business, but it is true that we could not work the way we do without custom cutting trees normally rejected by lumber brokers.

George Nakashima, like Soetsu Yanagi, exalted the dynamic beauty of irregularity, the inclusion and acknowledgement of imperfection as a way of achieving perfection. Working with the forms of nature, rather than against them, was a symbolic representation of his belief that Man must learn to work with Nature, rather than to dominate and conquer her, as modern society seems intent to do.

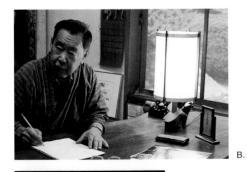

B.

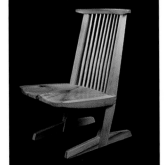

C.

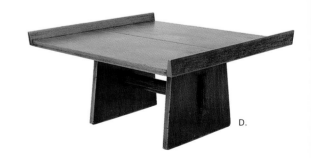

D.

A.
Redwood Root Burl Arlyn Coffee Table with walnut base, *1976*
photo: George Erml

B.
George Nakashima working on drawings in the Studio, c. 1983
photo: Osamu Murai

C.
Conoid Lounge Chair, *1980*
unfinished English walnut
photo: George Erml

D.
Teak Milkhouse Table, *1944*
photo: George Erml

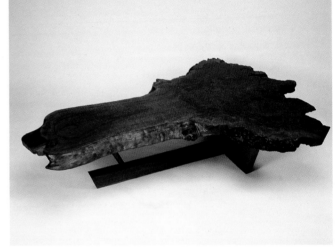

E.

E.
Walnut Odakyu cabinet with
"Asa-no-ha" doors from
Japan, *1976*
photo: George Erml

F.
Walnut Conoid Bench with
Back, *designed 1962
produced in 1974 for
Governor Nelson
Rockefeller's Japanese home
in Pocantico Hills*
photo: George Erml

G.
Claro and English Walnut
Burl Minguren II coffee table
*designed 1974, produced
1994*

H.
Black Walnut Armchair, *1944*
photo: George Erml

I.
*Installation of furniture for
Ultimo in Dallas, 1997*

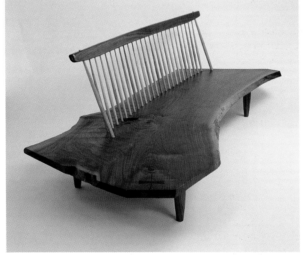

F.

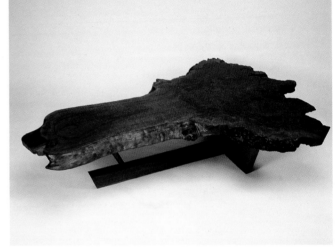

G.

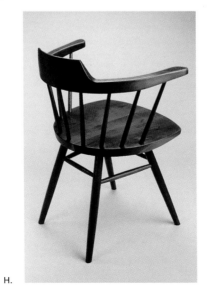

H.

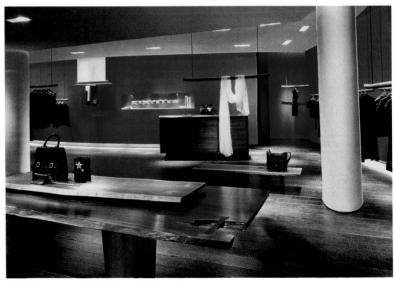

I.

Natural wood in our home and work and environment brings us in close proximity to Nature in a very real and tangible way, sometimes the only contact many of us have on a daily basis. It can also infuse us with a sense of peace so often lacking in the modern environment if we are open and aware of its power to do so. Making Nakashima furniture is indeed a way of life, combined with the hard-nosed reality of acquiring the finest wood available, designed with integrity and imagination, and crafted by hands trained to use both power and hand tools. It is the acknowledgement that wood has a life and energy of its own, that good craftsmanship and design must by nature be totally honest, and that Man is but a blip in the overall scheme of the Universe.

When my father passed away at the age of 85 in 1990, he was surprisingly at the peak of his career. In addition to the plethora of orders generated by the American Craft Museum Retrospective show, we were in the midst of trying to replace a 35-year collection of furniture occupying the entire house of Evelyn and Arthur Krosnick, which was destroyed by fire. It was an awesome task to follow in his footsteps, let alone try to fill his shoes, but I felt that my father would have wanted the work to continue, so we kept going as best we could. In 1993, Bruce Katsiff of the James A. Michener Art Museum in Doylestown, Pennsylvania, asked me to design and build a memorial reading room for my father in the new addition to the Museum, and the world began to know that Nakashima Studios was still alive under my direction.

In 1994, Mikio Shinagawa curated and sponsored a show of new pieces at the Tenri Gallery in New York, most of which were vertically displayed tabletops, and although the furniture sold very slowly, a new line of sculptural pieces came into being. As work was rather sparse during this time, I was able to indulge clients with small projects, such as candle-holders and mobiles, and to experiment with new bases for coffee and dining tables, outdoor benches and other special seating. I had the privilege of working with the architect Michael Gabellini on two rather extensive installations of the Ultimo Boutique in San Francisco and Dallas in 1997, the studio of jewelry designer Colleen Rosenblatt in Hamburg in 1998, and the boutique of Nicole Farhi in New York in 1999. In 1998, my new Keisho line debuted alongside vintage pieces at Robert Aibel's Moderne Gallery in Philadelphia.

One of our most important clients is the architect-developer David Hovey of Illinois, who heard my father's Mies Van Der Rohe Lectures series at Illinois Institute of Technology in 1977 and has been ordering furniture ever since. He has become a connoisseur and collector of rare woods, and as his residences are of a grand scale, has by now ordered the most large pieces in the history of Nakashima.

Perhaps my father was sent to teach all of us a lesson by creating a remarkably successful business based on hand craft and solid wood in a world of mass production and veneers printed on plastic. As Soetsu Yanagi's son Sori asserts, we can no longer afford to be a disposable culture, creating ever-growing mountains of garbage, including nuclear and chemical pollutants. We must tend to the world's forests, lest our supply not only of trees and wood, but of oxygen and other elements essential to life itself, be destroyed beyond replenishment. We must cherish the treasures of wood we have in our home and office environments and nurture these treasures of the future.

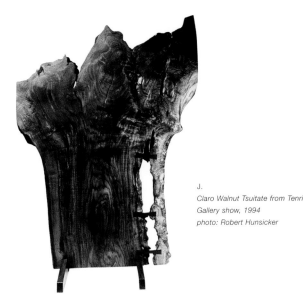

J.
Claro Walnut Tsuitate from Tenri Gallery show, 1994
photo: Robert Hunsicker

The real challenge, now that there are only three men from my father's original crew remaining, is to find and train a new generation who understand and appreciate the value of working up a sweat in shops with no air conditioning, sheds with no heat, being covered in wood dust, or patiently rubbing oil into wood to bring it to life.

For me, even one client in a hundred who is happy with their furniture not just because it is functional, but because it can be regarded as art, makes it all worth while. For now, the Nakashima tradition continues...

Mira Nakashima worked for many years with her father, George Nakashima, as a colleague and designer at Nakashima Studio in New Hope, PA. Since his death in 1990, she has been the creative director of the studio, where she continues to produce her father's classic furniture designs and to design and produce her own work as well.

George Nakashima and Mira Nakashima are both represented at SOFA by Moderne Gallery. Published in conjunction with the SOFA NEW YORK lecture *The Nakashima Legacy: Continuity and Change.*

What Postmodernism is Not!

Mark Del Vecchio

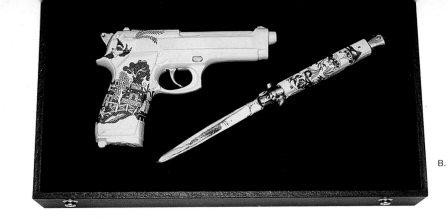

B.

When I recently gave a talk about postmodernism my audience expected that as an author of a book on the subject, I was going to define the term in a paragraph or two. This would have been both unwise and impossible. Asking what post-modernism is is much like asking "what is the meaning of life?" There are good answers but they tend to be long, complex, and highly subjective. Postmodernism is a big fat sprawling field. It is promiscuous, open to everything, all-inclusive and deliberately difficult to define. So instead of answering that question I am going to show you some of the cutting edges in postmodern art today and explain what postmodernism is "NOT."

My first "NOT" has to do with time and history, perhaps postmodernism's most important dynamic, and its most abused and over-exploited attribute. Modernism, with its emphasis on the new and on original authorship, effectively banished playing with the past, at least openly. So, for the first "NOT," postmodernism is NOT necrophilia. The point of postmodernism is not to make love to the dead but to take all the art and styles of dead artists as a resource so that they can be brought to life in a new context. The key phrase here is "brought to life."

As ceramics had a poor sense of self-history until about thirty years ago, any kind of reference to "the past" in recent years was hailed as a break-through of genius proportions. But postmodernists are neither antiquarians, nor curators. The whole point is transformation of past inheritance to give the present a fresh perspective. But we still see endless examples of ceramists who, simply by quoting Sung, Minoan, Renaissance or other periods, even with great skill and technical finesse, believe they are doing something profound. They are not. The act has to be more expansive, more of a revelation. It is like sampling in Hip Hop or Rap music. It needs to result in contemporary creation, not imitation, and to extend the metaphor, it must produce "new" music.

I will take a risky example. Some years ago I organized an exhibition, *Blue+White=Radical.* Blue and White is the most successful and ubiq-uitous style of decoration in all of ceramic history, maybe in all of decorative history. It featured, amongst other artists, Howard Kottler, one of the first postmodernists to shoot out of the gate in America, who was playing with this theme in the early 1970's. Presenting Blue and White within the mold, Kottler created an ironic comment on process and function in *Cup of Paisley* from 1973. Robert Dawson's *Perspective,* made 30 years later, is part of an elegant formal play with the "Blue Willow" design, the most successful single plate design ever, still being produced in millions of units a year today. Dawson has taken this design through a series of interpretations ending with one where he covers a plate with a detail from the design so enlarged that it makes no sense visually at all, leaving you with only one identifiable signal, "blue and white" itself.

Charles Krafft has done something different with his blue and white *Assassination Kit* [B]. Krafft began with making porcelain imitations of the weapons of the Eastern European secret police in Yugoslavia. This sets up a conflict between the harmless quality of the decorative, and the lethal objects that the blue and white adorns. It is a lesson on incongruity. Paul Scott's *Cumbrian Blue* in which the bucolic landscape we are accustomed to seeing in these blue and white chargers is sud-denly made menacing by the presence of a nuclear power station barely visible on the horizon. Both artists use the domestic comfort of blue and white to project a dissonant threat.

Philip Eglin uses blue and white to embrace the Staffordshire tradition of which he sees himself as part, living and working in Stoke-on-Trent, once the largest center of ceramic production in the world. But the painting of the surface is clearly contemporary. Laszlo Fekete from Hungary makes a wonderfully droll statement in his blue and white piece. He has taken two broken figurines from the Herend Porcelain Factory in Budapest. The figurines depict 18th century men, one being a nobleman who appropriately oozes blue blood and the other, a commoner, who bleeds common red.

Sometimes one can take on the past without mim-icking it. At the very core of Adrian Saxe's art is the history of 18th century court porcelains. While one might find an element or two from this source (such as handles taken from 18th century molds at the Sevres Porcelain Factory in France,) none of his pieces look anything like court porcelains. Think of his handsome *Antelope Jar* covered in gold glazed buttons and the *French Curve Teapot* [D] with its cobalt blue cactus finial. Both artworks are from the late 1980's, a particularly choice period in postmodern ceramics. Instead of achieving a visual resemblance to the 18th century inspirations, Saxe was trying to capture the "spirit" of the court porcelain and what it stood for. Refined taste, aris-tocratic privilege, in essence "beauty + taste + wealth = cultural power." He succeeds wonderfully.

A.
Paul Day
May Day, *2002*
Terra cotta
17.25 x 49 x 12

B.
Charles Krafft
Assassination Kit,
2000
whiteware, box
8 x 14.75

Richard Notkin, who I think has been a little under-valued of late, is one of the Masters of "pomo." In his case he does, to an extent, mimic the source of his inspiration, the 500-year-old Chinese tradition of Yixing, the source of the first teapots in the world. They were made with trompe l'oiel elements and were readable as symbols to everyday Chinese. They offered good luck, good fortune, good sex (large family), and so on. Notkin decided to take this idea and convert it into a Western concept, sending out messages in accessible, almost populist symbols. Highly political, he dealt with our questionable energy policies (or lack thereof) with his *Cooling Towers Teapot* [D], based on a Ming Yixing teapot made up of two boxes tied together. The *Cooling Towers* make for an elegant form but the thought of combining radioactive coolants with the nurturing warmth of afternoon tea, is a wonderfully unsettling comment. With the *Metamorphosis Teapot* from 1999, Notkin took the Yixing "Buddha's Hand" teapot which is modeled on the citron fruit, and found a visual similarity to the human heart. Notkin then took it all the way, created anatomically correct hearts and set up these objects as not symbols of man's compassion, but as small table top monuments to man's inhumanity to man, commenting on the Vietnam War, race riots and nuclear bombings. All of this in the guise of a teapot.

However his new work is growing beyond Yixing. The *Ruin,* a new series, is still a teapot but there is no precedent for this in Yixing. Wedgwood did a line of ruin ceramics in the late 1700's but that was not a source for Notkin either. This work grew out of his earlier 1970's exploration of the "prints" left on the side of buildings when the adjoining building was demolished. Also, he completed the first ruin a month before 9/11 so that was not the inspiration either, but it has subsequently changed his view about this work and its innate meaning.

In Notkin's case he has been an enormous influence on the very culture that he took from to make his work. In Yixing he is something of a god and the stamp of his imaginative reinvention of the Yixing teapot can be seen in every factory and workshop.

Appropriating from the past does not have to be limited to drawing from other art. One can take from anywhere. For Cindy Kolodziejski, it is the mid-century chemical lab that is her source. The stands are appropriated without change and the glass vessels have been molded and transferred into clay. What this does is add a sense of alchemy to her mix, giving her pots the feeling of some experiment or test – beautifully painted in glazes.

The next "NOT" involves decoration. One of post-modernisms great freedoms was in legitimizing pattern and decoration as worthy of serious art. But that did not mean that overnight all decoration *became* art. It just meant that art could be made with decorative intent or means. My rule here comes from the critic and theorist Amy Goldin who stated in 1977, "While decoration can be intellectually empty, it does not have to be stupid." Unfortunately a lot of decorative pottery today falls into the latter category.

We at Garth Clark Gallery were surprised when we got a *New York Times* review for an exhibition by Ralph Bacerra. We assumed that a fine arts critic would fail to see the art in the decorative excesses of Bacerra. We were wrong. Bacerra's mastery of the decorative verges on the magical. Ken Johnson, the *New York Times* art critic, got that point, and praised the honest virtuosity of this piece, wishing that conceptual art could acquire just a fraction of this sense of beauty.

Grayson Perry, who was this year's winner of the fine arts most prestigious award, the Turner Prize, appears to work decoratively but this is a Trojan horse... once one examines his work closely, the safety of the decorative retreats and one enters a radical transsexual world of dismemberment, sadomasochism, child abuse, the sexual peccadilloes of British royalty (past and present) and a host of other psycho-dramas that one would never expect to find within this decorative frame.

D.

E.

F.

C.

C.
Richard Notkin
Cooling Towers Teapot, *1987*
stoneware
6.5h
Collection of Gretchen Adkins
photo: Noel Allum

D.
Adrian Saxe
French Curve Teapot, *1987*
porcelain
11h

E.
Anne Kraus
The Green Bridge Motel, *2001*
earthenware
40 x 28.5

F.
Ralph Bacerra
Untitled Lidded Vessel, *2002*
whiteware
25 x 15
photo: Anthony Cunha

G.
Doug Jeck
Study in Antique White, *2000*
clay, hair, fabric, wood, plaster
54 x 60

H.
John Byrd
Monument for Laika, *2001*
porcelain, taxidermy, mixed media
14 x 13 x 10

Anne Kraus, who passed away last year at the young age of 47, used the same device. The sense of being decorative gives those who handled and examined her work an initial feeling of comfort but then as they viewed her vignettes and read the words taken from her dream diaries, they realized that they were entering a landscape of fear, alienation and thwarted love.

The next "NOT" is the figure. Yes, postmodernism did bring the figure back to respectability. That is not the problem. The problem is that figurative ceramics today are being made mostly by ceramists who cannot draw a convincing human figure if their life depended on it. About ninety per cent of portfolios submitted to the gallery are of figurative art. Most are grossly inept. So the rule is "You can fake many things but you cannot fake the figure." We are figures ourselves so we look at the figure in art and know instantly whether or not it is authentic. By that I mean, do they contain convincing human gesture and spirit? This does not mean being an old-school realist.

The figure can be abstracted as in the case of the Ron Nagle's *Snuff Bottles,* but we have to feel the confidence that the artist has a real grasp of human form. These forms are in essence figurative forms, some full bodies, others very distinct body parts and Nagle was himself shocked when this work emerged. He had been avoiding the figurative his entire career and never expected to work in this arena. But it is a wonderfully refined sexual shift, almost lewd, and even though the elements are the same as in his cups, it changes his aesthetic meaning. For instance when you look at the juicy, oozing glaze drips on these pieces, it's not the Momoyama tea bowls that comes to mind but rather body fluids of the sexiest kind. They are playful tongue-in-cheek exercises for the visually acute.

In his most recent exhibition Akio Takamori takes on the powerful women of history, expressing this by contrasting East with West. From the East he selected those extraordinary Tang tomb figures as his starting point, amongst the most beautiful ceramic figures ever made, focusing particularly upon their dramatic hair. He began to realize that power with women was tied to their hair-dos and taking that a step further, realized that elaborate hair is often very sexual in form. From the West he pillaged the old masters, drawing inspiration from Goya, Velasquez and Bruegel. Individually his figures, painted into life, are intriguing but it is the cross-cultural visual dialogue that brings these figures most vividly to life.

G.

H.

Doug Jeck, one of the current masters of the figurative genre, brings a neo-classical sensibility to the clay figure that is unequaled in the sheer brilliance of his modeling and grasp of human form. These slightly-smaller-than-life-figures begin as classically perfect forms, and then starts the process of mutilation. Actually it is self-mutilation in a sense even though these are not self-portraits per se. But the injury they suffer is the injury of a life lived. Jeck draws on his own damage in growing up, and what better proxy for this inner journey of pain than "Jesus and the Crucifixion." This is not an easy sculpture to look at, but it is one of the most major single figurative works from ceramics since 1950. That is, of course, just my opinion. At times Jeck is able to create surprising repose amongst the pain, injury and missing limbs as in his *Study in Antique White* [G], a haunting imaginary portrait of a man with Downs Syndrome posed as though he is Manet's *Olympia*.

Both Jeck's work and the sculpture by his one-time student John Byrd, emphasize a growing dilemma for ceramics. Little of the cutting edge work today is purely ceramic. It is increasingly multimedia. At times ceramics can be the lesser part of the total piece. What does this say about the future for our medium? At which stage does it cease to be ceramics and simply become multimedia sculpture? John Byrd combines clay with taxidermy, encasing the trophy heads in resin. These works have to do with the food chain as they are more about man than animal. In part they are humorous, albeit darkly so, and Byrd's favorite artist is not Damien Hirst, but rather the Italian artist Maurizio Cattelan, who has also played with taxidermy in his work.

Adelaide Paul also uses animal themes in her work, but she has a political agenda, even a propagandist one. As a parent of greyhound rescue dogs, dogs that have been saved from the race track, she has been able to translate this into painful, vivid imagery in small scale as in *Win/Place/Show*, which suggests crucifixion at the church of gambling and the dogs being sacrificed to man's addictive vice. This is not the only theme in her work but it is a potent one and her modeling is painfully tender.

Then we have the work of Paul Day, a British artist working in France. He plays with Renaissance terra cottas and with the notions of perspective and relief sculpture that were developed centuries ago. The area that he is mining would have been considered heresy during the modernist regime. And it is something of a throwback but a mesmerizing one and involves an understanding of perspective that few artists possess today. In *Le Sacre Coeur* one can see the formal quality of his skills in the way that he can give life to architectural space. One can confront his imagination in this remarkable view of life through sunglasses titled *May Day* [A] that takes classical terra cotta sculpture into the present.

Now for the last of the "NOT's." Postmodern is not necessarily anti-modern. In fact there are new strains of modernism growing out of postmodernism everyday. There are several movements in architecture and design, among them "Super-Modernism" and "Tech Nouveau". Both are based, and I am simplifying here, on the notion that artists who worked in art nouveau or modern styles were limited, even blunted, in their aesthetic goals by the boundaries of technology as they existed at that time. New technology means that some ideas from these movements can now be taken much, much further because of new materials and new technologies, so old ideas can have new vitality.

J.

That is expressed to some extent in what I refer to in my book as "Post Industrialism." In part it is sentimental and nostalgic—pre-computer memories of the old factories with their iron machines where grandpa went to work. But much of this work lives on the cusp of what we can describe as neo-modernism. Since my book appeared there have been a number of exhibitions exploring this aesthetic. Marek Cecula is the most important figure in this movement. His 1993 exhibition *Scatology* was a turning point for the field and in reviewing the hundreds of portfolios we receive every year, it is clear Cecula is one of the most imitated and most referenced ceramic artists today. Cecula works within an industrial aesthetic, something he understands because he is also an industrial designer, and one sees this sensibility in the installation view of his 2002 show *Interface.*

His great tours-de-force is his *Porcelain Carpet Project.* It exists because of new technology that allows him to create a full-color life-size decal of a 9 foot x 12 foot 19th century Indian carpet that he transferred onto 260 dinner plates. It is a dazzling piece to confront and set out on the floor – it presents a wonderful tease. Plates belong on tables and rugs belong on floors. The incongruity of this idea resonates throughout your entire physical being.

"Installations" should be on the "NOT" list and not just because they have been over explored in the last forty years. However there are ultimately no rules to art and some installations can still break new ground. Denise Pelletier's *For Mary* [I] is one example created from hundreds of what were known as "sick cups", industrially made Victorian objects used to feed the sick. Aside from the formal beauty of this piece, which still stuns me every time I see the image, Pelletier has managed to create what is in effect a "vast floating sea of compassion."

Whether one likes it or not, this Post Industrial, neo-Modernist surge seems to be the strongest single aesthetic in ceramics today. And I make that statement because I know that many people come to ceramics for its earthy, homey charms, the warmth of its material, and the handprint of the artist, the richness of its glazes and the romance of the fire. They also admire its familiarity and its intimacy. But staying in the same place is not what growth in art is about. We can mourn the past but we have to accept and embrace the dawn of a new day. For both collector and artist, art should never become a comfort station. It should be a place of stimulation.

So I would invite those of you who feel concerned about this direction to perhaps give it a second look. There are wonderful things happening in this genre.

With that in mind I will close with work from Philadelphia's Clay Studio gallery last year. In Julie York's provocative exhibition *objectsymbolanguage,* we see many pointers to the future – the emphasis on multi-media, again to the point where it is no longer really ceramics as we once knew it, the advance of the industrial aesthetic over that of the crafts, the emphasis on intellectual content over tactility, and expressions of function as a conceptual notion.

And for the foreseeable future this is one of the strongest directions we see in ceramics. Its objectivity, its distance from a material sentimentality, its intelligence, its cool approach to process is welcome. York's work arrives like icy sherbet served between courses to refresh a mind numbed by the heaviness of clay as primordial mud.

Postmodernism never made the proposition that *anything* is art, it merely offers the freedom that an artist can use anything to *make* art. The boundaries are all gone, which as we well know is a dangerous circumstance. It means that each artist must establish his or her own criteria. And because of this permissiveness we have to become tougher critics and separate the poseur from the true creator. Only a small part of what is made under the postmodern banner has value. The key to judging this is simple and complex—transformation—what did you inherit and to what extent did you transform your inheritance? Or maybe you did not transform your inheritance at all and only managed to reproduce it, in which case you have failed. Postmodernism is as generous as it is unselective, giving everyone enough rope to fashion a ladder of their own imagining and scale the most ambitious aesthetic heights. But it also provides enough rope for you to hang yourself.

Mark Del Vecchio has been a leading figure promoting scholarship in ceramics for over twenty years. Based in New York, he was co-chair of the organizing committee for the groundbreaking 1999 Ceramic Millennium Leadership Congress in Amsterdam and is a founding director and partner in the Garth Clark Gallery, New York. He is also the author of *Postmodern Ceramics* published by Thames & Hudson, London which *The Art Book* described as "one of the best survey monographs on ceramics".

Published in conjunction with the SOFA NEW YORK lecture *What Postmoderism is Not!*

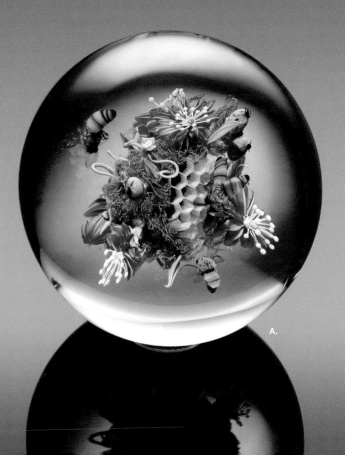

A.

Paul Stankard: Forty Years
of an American Master in Glass

Jennifer Scanlan

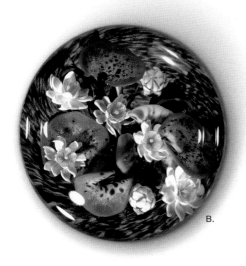

B.

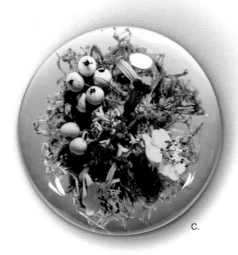

C.

D.

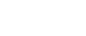

One day last January, Paul Stankard assembled his life's work on two long tables in his dining room in Mantua, New Jersey. Together with curators from the Museum of Arts & Design, he was selecting pieces for the upcoming exhibition *Paul Stankard: A Floating World – Forty Years of an American Master in Glass*. The pieces told a story of constant exploration, of a love of beauty and nature, of a quest for poetry and spirituality, and of a passion for glass and all of its artistic potential in a career that has spanned four decades.

Stankard's crystal-encased floral sculptures have their origins in the flameworked paperweight tradition, though he has extended the boundaries of that tradition, developing entirely new forms and techniques. The beauty and intimacy of his creations have made him enormously popular across a wide spectrum of glass enthusiasts, sought after by collectors, and praised by critics. He has bridged the gap between paperweight collectors and studio glass enthusiasts, and he attracts many new fans with his vibrant colors and amazing details that reveal themselves completely only after many viewings.

As a child Stankard was fascinated by the wildlife beyond the edge of his parents' backyard in North Attleboro, Massachusetts. His love of nature stayed with him after the family's move to southern New Jersey, where he studied glassmaking at Salem County Vocational Technical Institute. He graduated in 1963 and began to work in industry, making glass instruments for laboratories. He found the work interesting when technically challenging, for it required both mental and physical efforts to develop the skills to create a new form. Once he

had mastered each project, however, the process would become less appealing, and out of boredom he began to explore new ways to work with the medium. He remembers, "When I worked in industry, I was always fascinated by the creative side of glass." Aware of Harvey Littleton's art glass workshops in Toledo and the nascent studio glass movement, he was inspired to express his artistic side in his free time. In the evenings and weekends, he created flameworked animals that he sold for 35 cents each.

At the same time, Stankard was increasingly drawn to the paperweight as a vehicle to express his interest in flowers. Southern New Jersey, Millville in particular, had a tradition of paperweights that went back to the turn of the century, and was especially noted for the "Millville Rose" floral paperweight. In the mid-twentieth century, Charles Kazium and later Francis Whittemore revived the New Jersey paperweight tradition. Stankard befriended Whittemore in the early 1960s and discussed traditional paperweights with him. As his curiosity deepened, Stankard became interested in the nineteenth-century floral paperweights of the French firms Baccarat and Clichy, and studied scientific glass creations of the Blashka father-and-son team, whose astonishingly lifelike flowers were created for botany students at Harvard in the late nineteenth and early twentieth centuries. He says, "The idea that the secrets had been lost interested me." Always ready for another challenge, he began to explore the technical process, teaching himself, through books and experimentation, skills that had remained secrets for almost a hundred years. In 1969, he stopped creating flameworked animals in order to concentrate on paperweights, though he was still working on the "creative side of glass" only during his free time.

A turning point came in 1971, when Reese Palley, the owner of a gallery in Atlantic City, saw Stankard's paperweights at the Indian Summer Art Show.

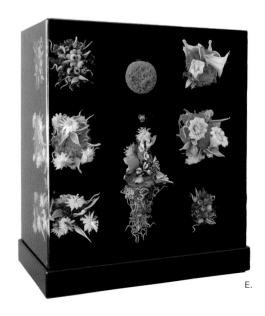

E.
Native Flowers Bouquet
Cloistered Assemblage, *2003*
glass
Collection of Josh Steindler
photo: Douglas Schaible

Palley began to represent Stankard at his gallery, and the following year he encouraged Stankard to leave his job in industry and devote himself full-time to his art. While Stankard was relieved to be leaving an industrial culture that he found rigid and restricting, he notes, "My work wouldn't be the same today if it weren't for the industrial training."

Stankard departed from the stylization of his French models in his interpretation of wildflowers and more realistic representations of plants and insects. Stankard's floral forms were inspired by nature preserves close to his home in southern New Jersey such as the Pine Barrens woodlands and Longwood Gardens, as well as memories from his own childhood. His exploration of wildlife led to portrayal of all of the stages of the plant, from seed to flower to berry, demonstrating the cycles of life. With the addition of insects, he sought to show the interdependence of all life forms. Not content with realistic detail, Stankard used natural forms as a personal metaphor for deeper meanings and messages.

From the beginning, he tried to move away from the horizontal format characteristic of the round paperweight form to a vertical composition. In an early experiment of 1972 he encased a glass flower in acrylic in an upright rectangular form. Eventually, as his works became taller and more rectangular, he was able to replicate this experiment in glass. By the 1980s, he had developed the Botanical, a block form that allowed the arrangement inside to be viewed from all sides, giving the work a sculptural presence. At the same time, the form represented a major challenge for Stankard: conceived in two sections and created in six steps, the Botanicals were thus much more conceptually complex, as well as riskier to produce, than the paperweights.

This risk-taking was evidence of his increasing connection to the world of studio glass. In 1975, he met Harvey Littleton and Dominick Labino at a symposium on contemporary glass held at the Bergstrom-Mahler paperweight museum in Wisconsin, at a time when, he recalls, there was less of a division between studio glass and paperweights. Two group exhibitions in the late 1970s, at the Habatat Gallery in Michigan and at the Corning Museum of Glass in New York, introduced Stankard to a national audience. A solo exhibition at The Contemporary Art Glass Gallery (now Heller Gallery) was what Stankard called "an epiphany." He remembers, "When I brought the work to the Heller Gallery and I saw them display it on pedestals, I saw [the work] displayed in a fine art context for the first time." Increasing acclaim for his work allowed him to set higher prices, which in turn gave him the freedom to continue experimentation. After attempting on and off for five years to create mountain laurels, he decided to focus on capturing the form. For an entire month no salable work was produced, as experiment after experiment failed. Finally, as he was going to bed one night the solution came to him. When he woke up the next morning, he went straight to his studio to create one of the most beautiful and evocative of his floral designs.

As Stankard's work evolved, he began to incorporate elements that were not representations of natural forms, but symbols of larger meaning. In 1982 his interest in the metaphysical connection between humans and nature led to the addition of "root people," small forms that appeared intertwined in the roots of his plants, which were based on anthropomorphic illustrations in medieval herbal books. Small word canes began to be significant

elements of his design: words such as "fertile" and "seeds" suggested the life cycle of all growing things. Most recently he has added masks, which lend his works the aura of the eternal.

In the past fifteen years, Stankard's work has been shown in national and international venues of increasing importance, including Venzia Aperto in Venice, Italy; the Museum of Fine Arts in Boston, Massachusetts; the Renwick Gallery of the Smithsonian Institution in Washington, D.C.; the Design Center Ishikawa, in Kanazawa, Japan; and the 2001 Contemporary Glass Exhibition, in Beijing and Shanghai, China. He has shared his skills and knowledge with a new generation of glass artists, teaching at the Pilchuck Glass School in Seattle, Washington; the Penland School of Crafts in Penland, North Carolina; and setting up the art glass program at his alma mater, now called Salem Community College.

Though his work has achieved worldwide recognition and acclaim and is included in more than forty public collections, Stankard continues to experiment with new forms and techniques. The Cloistered Botanicals are fused with colored glass on the

F.

F.
Mountain Laurels
on hot plate
glass
photo: John Bigelow Taylor

G.
Damselfly over Tea Roses,
Blueberries and Bulbous
Roots Botanical, *2003*
5.75h, glass
photo: Douglas Schaible

H.
Raspberries, Forget-Me-Nots
and Damselfly with Golden
Bowl (underside detail), *1995*
glass
Collection of Annie and
Mike Belkin
photo: John Bigelow Taylor

I.
Deptford Pink Cloistered
Botanical, *1986*
5.5h, glass
Collection of Annie and
Mike Belkin
photo: John Bigelow Taylor

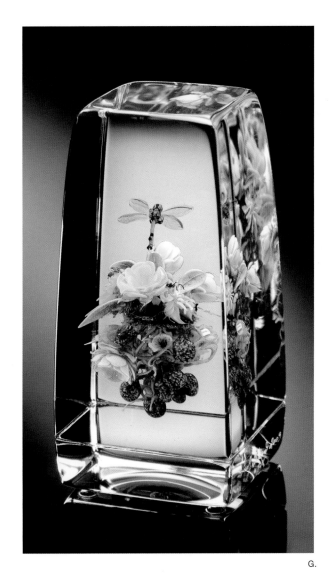

G.

H.

I.

back, resulting in a more dramatic reading of the arrangements. His large-scale Assemblages, incorporating as many as nine elements, are based on one floral study, which he then explores in greater depth in each individual part. Stankard's most recent creations, Orbs, are completely spherical and made with optical quality glass, magnifying the details within. Even after forty years, Stankard still has a strong need to explore, to grow and develop, and to expand the boundaries of his artwork.

Last January, as he looked at the collection of his work and thought back over his career, Stankard noted the factors that had been most significant to his development as an artist. He cited his connections to the people around him: friends and mentors Reese Palley, Mike Belkin and Mike Diorio; his assistants, Dave Graeber and his children Christine, Pauline, Katherine and Joseph; and his wife Patrica, to whom all of the pieces in his own collection were dedicated. He also noted the importance of taking risks, difficult for him, with his passionate investment in each piece, yet necessary for him to bring the work beyond technical mastery to the realm of art. Perhaps most essential was what he calls "depth of feeling," which Stankard considers an element of all great art, be it glass sculpture, music, literature, or poetry. He observes that this last quality has come with his maturity as an artist, and his exposure through books to the great ideas of civilization. As he continues to experiment and to take joy in new discoveries, it is clear that *Paul Stankard: A Floating World* is not a definitive retrospective, but another chapter in the development of this American master.

Jennifer Scanlan is Assistant Curator at the Museum of Arts & Design. Together with David McFadden, Chief Curator and Vice President for Programs and Collections, she organized the exhibition *Paul Stankard: A Floating World/Forty Years of an American Master in Glass.* This exhibition will be on display at MAD from May 28 through August 29, 2004.

Paul Stankard is represented at SOFA NEW YORK by Marx-Saunders Gallery, Ltd., and is a speaker in this year's lecture series.

hibitors

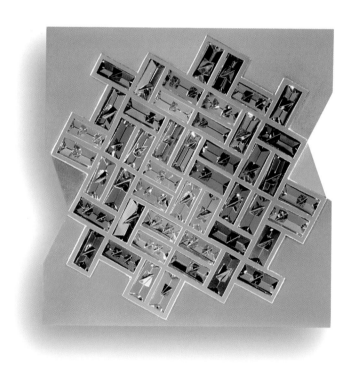

Bernd Munsteiner, **Reflections** *pendant, 2003*
18k gold, aquamarine, golden beryl, peridot, tourmaline, 2.75 x 2.75

Aaron Faber Gallery

100 Years: Design in Jewelry; special presentation at SOFA NEW YORK: Focus on Enamels Part II
Staff: Edward Faber; Patricia Kiley Faber; Felice Salmon; Erika Rosenbaum; Jackie Wax; Jerri Wellisch; Sabrina Danoff; Roxanne Awang

666 Fifth Avenue
New York, NY 10103
voice 212.586.8411
fax 212.582.0205
info@aaronfaber.com
aaronfaber.com

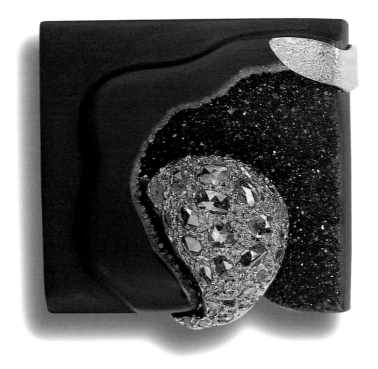

Lina Fanourakis, **Black Drusy Brooch**
18k gold, 17.50 ct. black drusy quartz, 3.75 ct. rose-cut diamonds, 2 x 2

Representing:
Glenda Arentzen
Margaret Barnaby
Marco Borghesi
Ute Buge-Buchert
Chavent
Devta Doolan
Joseph English
Lina Fanourakis
Michael Good
Christine Hafermalz-
 Wheeler
Marianne Hunter
Enric Maioral
Bernd Munsteiner
Jutta Munsteiner
Tom Munsteiner
Tod Pardon
Linda Kindler Priest
Susan Kasson Sloan
Jeff Wise
Susan Wise
Michael Zobel

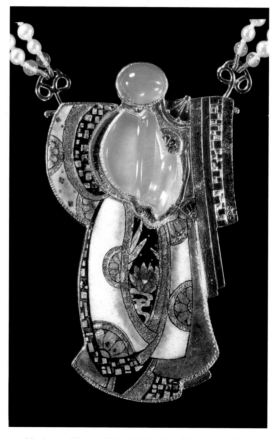

Marianne Hunter, **Kabuki Kachina Draped in Twilight**
grisaille enamel with foils, 24k, 14k, sterling silver, lavender chalcedony,
carved holly blue chalcedony, 2.75 x 1.625 x .25
photo: Hap Sakwa

Aaron Faber Gallery

Special SOFA NEW YORK presentation: *Focus on Enamels II*

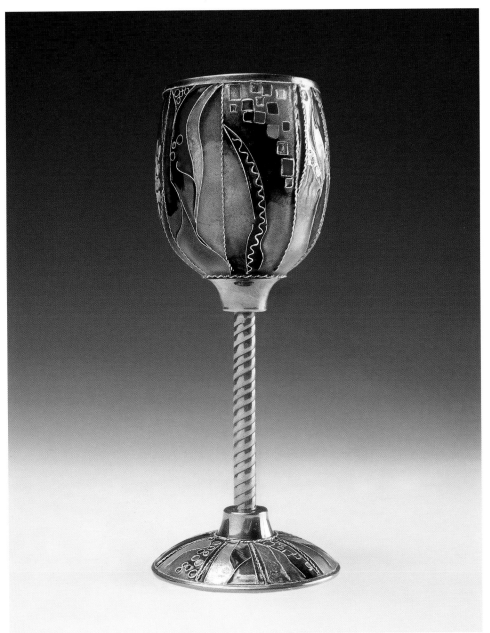

Representing:
Jessica Calderwood
Linda Darty
Erica Druin
Marilyn Druin
Michael Good
April Higashi
Melissa Huff
Marianne Hunter
Fredricka Kulicke
Richard McMullen
Larissa Podgoretz
Sydney Scherr
Marian Slepian
Judy Stone
Ginny Whitney

Marian Slepian, **Wedding Cup,** *2003*
fine sliver cloisonné enamel on fine silver, set in 24k gold-plated sterling, 24k gold, 6.5 x 2.5

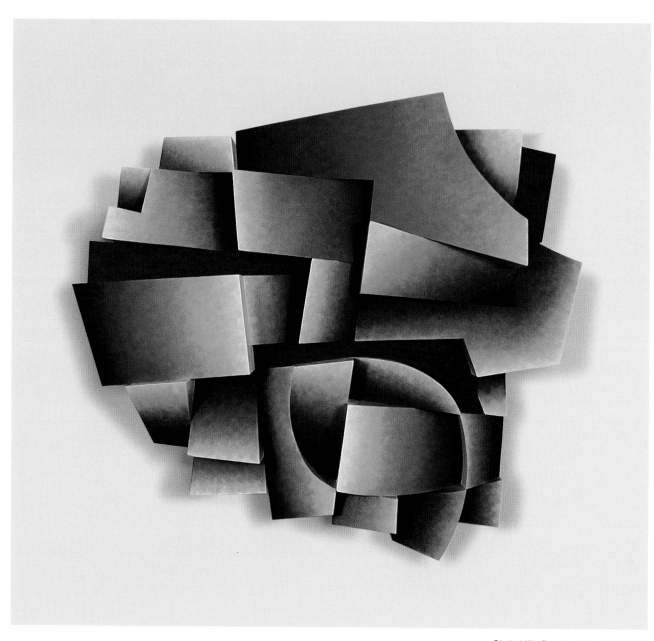

Chris Hill, **Comfort Derived***, 2004*
welded steel, acrylic paint, 48 x 54 x 10

Ann Nathan Gallery

Artist-made furniture, sculpture and paintings by prominent and emerging artists
Staff: Ann Nathan, director; Victor Armendariz, assistant director

212 West Superior Street
Chicago, IL 60610
voice 312.664.6622
fax 312.664.9392
nathangall@aol.com
annnathangallery.com

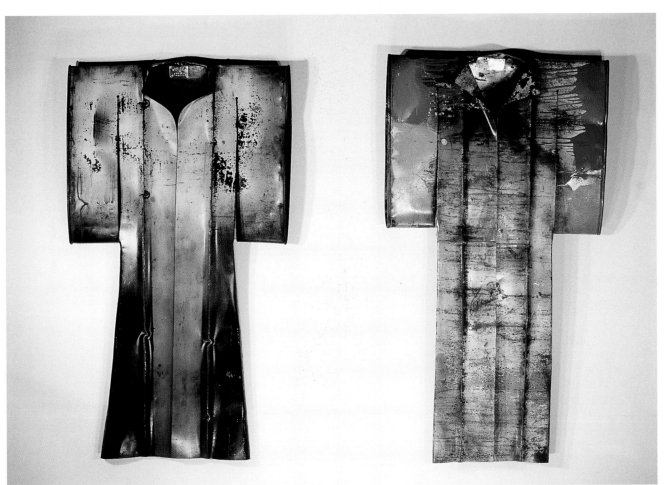

Representing:
Pavel Amromin
Mary Bero
Gordon Chandler
Cristina Cordova
Matt Davey
Gerard Ferrari
Krista Grecco
Michael Gross
Chris Hill
Jesus Curia Perez
Jim Rose
Michael Speaker
Tibor Timar

Gordon Chandler, **Kimonos**
steel drum, 60 x 36 x 6

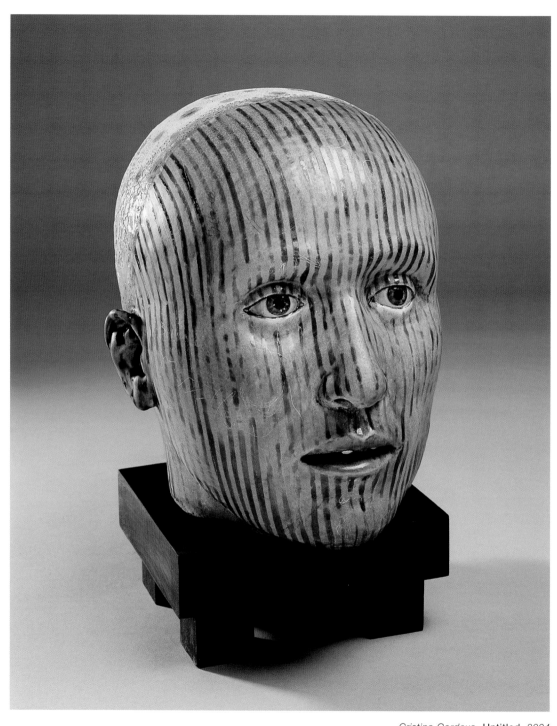

Cristina Cordova, **Untitled,** *2004*
earthenware, etched glaze, stains, overglaze, 10 x 9 x 10

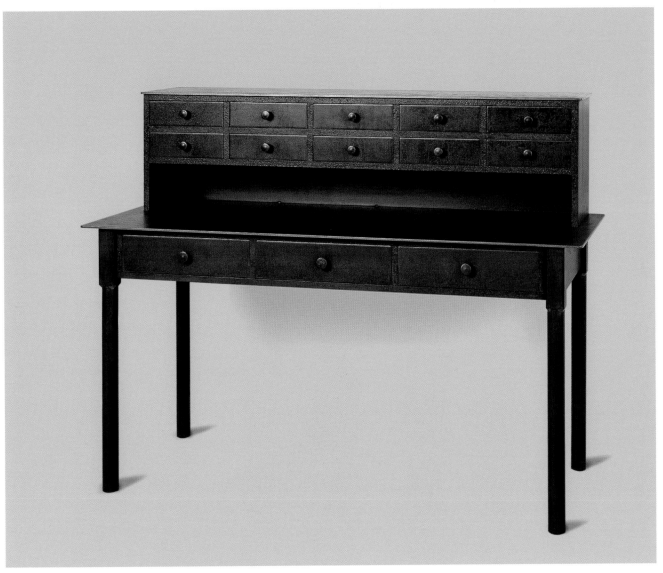

Jim Rose, Desk, *2003*
steel, natural rust patina, 44 x 58 x 24

Celia Marco del Pont, **Serie: The Lady of Desire,** *2004*
metal (graver), wood, print paper, 19 x 15 x 1.5

Artempresa Gallery

Latin American artistic expressions

Staff: Maria Elena Kravetz, director; Raul Nisman; Matias Alvarez, assistant

San Jeronimo 448
Cordoba 5000
Argentina
voice 54.351.422.1290
fax 54.351.427.1776
artempresa@arnet.com.ar
artempresagallery.org

Representing:
Luis Bernardi
Leonor Goldenberg
Rosario Guillermo
Sol Halabi
Celia Marco del Pont
Ana Mazzoni
Shona Nunan
Silvia Parmentier
Gabriela Perez Guaita
Leah Poller
Margarita Selva
Salvador Susarte
 Molina
Maria Alejandra Tolosa

Silvia Parmentier, **Signals II,** *2003*
glass, metal, 11 x 17 x 4

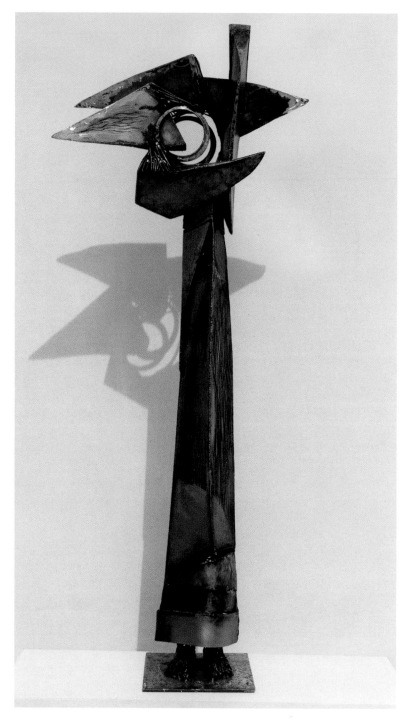

Gabriela Perez Guaita, **The Lighthouse,** *2003*
metal, 69.5 x 28 x 12

M. Alejandra Tolosa, **The Coffer,** *2004*
oil on carved wood, 19.5 x 10 x 6

Michael Glancy, **Transfixed Vortex,** *2003*
deeply engraved Pompeii cut blown glass, industrial plate glass, copper, 13 x 18 x 18
photo: Gene Dwiggins

Barry Friedman Ltd.

Contemporary decorative arts, including glass, ceramics, furniture, wood and metal
Staff: Barry Friedman; Carole Hochman, director; Erika Brant; Lisa Jensen; Marc Benda; Spencer Tsai; Craig Barron

32 East 67th Street
New York, NY 10021
voice 212.794.8950
fax 212.794.8889
contact@barryfriedmanltd.com
barryfriedmanltd.com

Representing:
Giles Bettison
Jaroslava Brychtová
Laura de Santillana
Ingrid Donat
Erwin Eisch
Michael Glancy
William Hunter
Stanislav Libenský
Massimo Micheluzzi
William Morris
Yoichi Ohira
František Vizner
Toots Zynsky

Erwin Eisch, **Hommage auf Picasso***, 1992*
glass, blown in a mold, manipulated while hot, with enamel decoration, 20.75 x 11 x 14
photo: Spencer Tsai

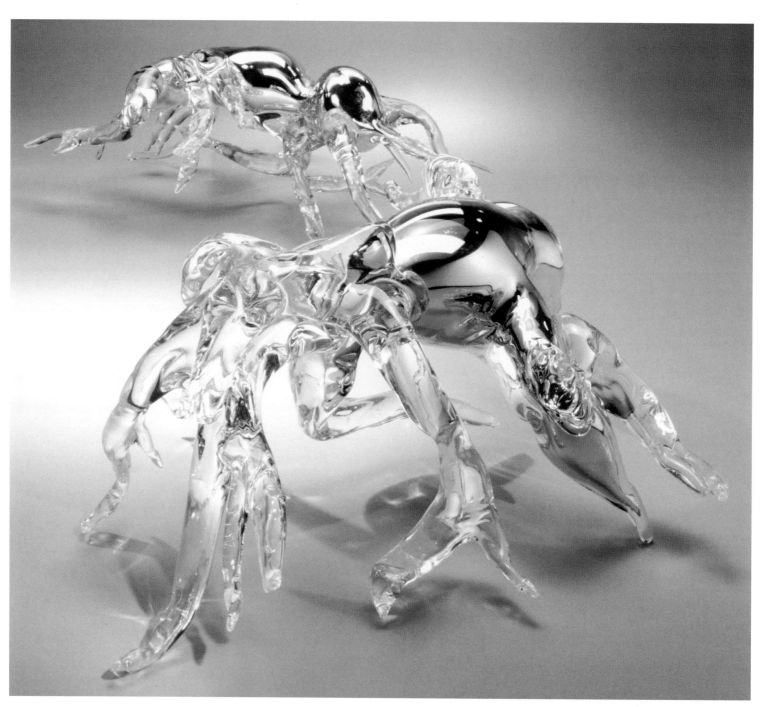

Marya Kazoun, **Self Portrait,** *2003*
mirrored glass installation
photo: F. Ferruzzi

Berengo Fine Arts

Contemporary art in glass
Adriano Berengo; Marco Berengo

Fondamenta del Vetrai, 109/A
Murano, Venice, Italy
voice 39.041.527.6364
fax 39.041.527.6588
adberen@berengo.com
berengo.com

Representing:
Luigi Benzoni
Ernst Billgren
Martin Bradley
James Coignard
MarieLouise Ekman
Gerda Gruber
Ursula Huber
Marya Kazoun
Riccardo Licata
Bengt Lindström
Irene Rezzonico
Juan Ripollés
Koen Vanmechelen
Claude Venard
Silvio Vigliaturo

Silvio Vigliaturo, **Il Giullare e la Bella,** *2002*
glass, 42.75 x 21.75 x 7
photo: F. Ferruzzi

Dan Dailey
LE7/6 Female Figurative Floor Lamp FP, *2000*
cast bronze, anodized aluminum, vitrolite mosaic vase, glass, gold plated details
72h with 44 x 28 base
photo: Winston Boyer

Brendan Walter Gallery

Master and vintage blown glass, decorative arts
Staff: Brendan Walter, director; Michael Schunke; Rebecca Myers

960 Alameda Street
Monterey, CA 93940
voice 831.373.6900
fax 831.373.0900
brendanwlt@aol.com

Representing:
Jaroslava Brychtová
William Carlson
Wendell Castle
Dale Chihuly
Dan Dailey
Jun Kaneko
Joey Kirkpatrick
Stanislav Libenský
Flora Mace
Dante Marioni
Paul Marioni
Richard Marquis
William Morris
Rebecca Myers
Albert Paley
Michael Schunke
Brendan Walter

Wendell Castle
Once Upon a Time, *1987*
stained birdseye maple, cherry, gilded mahogany, acrylic paint, clockworks
103 x 40 x 14

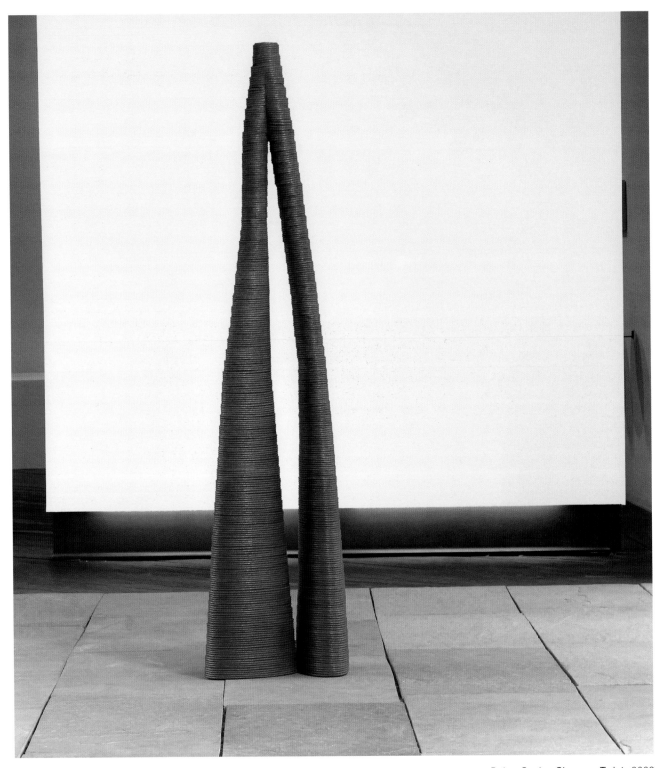

*Debra Sachs, **Siamese Twist**, 2003*
wood, paper, twine, steel gimps, mixed polymers, 86 x 20 x 14
photo: Tom Grotta

browngrotta arts

Focusing on fiber art for 17 years Wilton, CT
Staff: Rhonda Brown and Tom Grotta, co-curators; Roberta Condos, associate voice 203.834.0623
voice 800.666.0623
fax 203.762.5981
art@browngrotta.com
browngrotta.com

Representing:

Adela Akers	Inge Lindqvist
Dona Anderson	Åse Ljones
Jeannine Anderson	Kari Lønning
Marijke Arp	Astrid Løvaas
Jane Balsgaard	Dawn MacNutt
Jo Barker	Ruth Malinowski
Dorothy Gill Barnes	Rebecca Medel
Caroline Bartlett	Mary Merkel-Hess
Dail Behennah	Judy Mulford
Nancy Moore Bess	Leon Niehues
Birgit Birkkjaer	Keiji Nio
Sara Brennan	Greg Parsons
Jan Buckman	Simone Pheulpin
Pat Campbell	Valerie Pragnell
Chunghi Choo	Ed Rossbach
Chris Drury	Scott Rothstein
Lizzie Farey	Mariette Rousseau-
Mary Giles	Vermette
Linda Green	Debra Sachs
Françoise Grossen	Toshio Sekiji
Norie Hatekayama	Hisako Sekijima
Ane Henricksen	Kay Sekimachi
Maggie Henton	Carol Shaw-Sutton
Helena Hernmarck	Hiroyuki Shindo
Sheila Hicks	Karyl Sisson
Marion Hildebrandt	Britt Smelvær
Agneta Hobin	Jin-Sook So
Kazue Honma	Grethe Sørenson
Kate Hunt	Kari Stiansen
Kristín Jónsdóttir	Noriko Takamiya
Christine Joy	Chiyoko Tanaka
Glen Kaufman	Hideho Tanaka
Ruth Kaufmann	Tsuroko Tanikawa
Tamiko Kawata	Blair Tate
Anda Klancic	Lenore Tawney
Lewis Knauss	Jun Tomita
Mazakazu Kobayashi	Deborah Valoma
Naomi Kobayashi	Claude Vermette
Nancy Koenigsberg	Ulla-Maija Vikman
Yasuhisa Kohyama	Kristen Wagle
Irina Kolesinikova	Wendy Wahl
Markku Kosonen	Katherine Westphal
Kyoko Kumai	Jiro Yonezawa
Gyöngy Laky	Masako Yoshida

Jo Barker, **Halo,** *2003*
cotton warp, wool, cotton embroidery and metallic threads, 36 x 44
photo: Tom Grotta

Mariagrazia Rosin, **Medussiano,** *2003*
glass, 55 x 20
photo: Mario Cresci

Caterina Tognon Arte Contemporanea

Contemporary glass sculpture by European and American artists
Staff: Caterina Tognon, director; Sergio Gallozzi, assistant director; Galliano Mariani, assistant

Via San Tomaso, 72
Bergamo 24121
Italy
voice 39.035.243300
fax 39.035.243300
caterinatognon@tin.it
caterinatognon.com

Representing:
Maurizio Donzelli
Silvia Levenson
Richard Marquis
Mariagrazia Rosin

Richard Marquis, **Bottle Truck,** *2003*
fused glass with murrine, wooden wheels, 8 x 16.25 x 5.25

Toshio Iezumi, **F011203**, *2003*
laminated plate glass, 10 x 12 x 12
photo: Toshio Iezumi

Chappell Gallery

Contemporary glass sculpture

Staff: Alice M. Chappell, director; Vivienne A. Bell, gallery manager and curator, New York

14 Newbury Street
Boston, MA 02116
voice 617.236.2255
fax 617.236.5522

526 West 26th Street, #317
New York, NY 10001
voice 212.414.2673
fax 212.414.2678
amchappell@aol.com
chappellgallery.com

Representing:
Maryann Babula
Alex Gabriel Bernstein
Lyndsay Caleo
Kathleen Holmes
Toshio Iezumi
Yoko Kuramoto
David Murray
Kait Rhoads
Joyce Roessler
Takeshi Sano
Youko Sano
Gale Scott
Lada Semecká
Naomi Shioya
Jan Štohanzl

Alex Gabriel Bernstein, **Ice Fall**
cast and cut lead crystal, fused steel, 16 x 12 x 12

Naomi Shioya, **Door Like a Page**
cast glass, 9.5 x 9.5 x 4.25
photo: James Dee

Kait Rhoads, **Sargasso Column Peacock Vase***, 2003*
blown glass, olive green transparent zanfirico cane, peach and gold murrine, 16 x 8 x 3.5
photo: Roger Schreiber

Bruce Metcalf, **Brooch***, 2003*
carved wood, gold leaf over brass
photo: Karen Bell

Charon Kransen Arts

Contemporary innovative jewelry from around the world
Staff: Adam Brown; Lisa Granovsky; Charon Kransen

By Appointment Only
357 West 19th Street, Suite 2E
New York, NY 10011
voice 212.627.5073
fax 212.633.9026
chakran@earthlink.net
charonkransenarts.com

Representing:

Efharis Alepedis	Miguel
Till Baacke	Barbara Paganin
Ralph Bakker	Gundula Papesch
Rike Bartels	Annelies Planteydt
Michael Becker	Todd Reed
Liv Blavarp	Jackie Ryan
Antje Braeuer	Lucy Sarneel
Anton Cepka	Fabrice Schaefer
Petra Class	Sylvia Schlatter
Giovanni Corvaja	Renate Schmid
Simon Cottrell	Claude Schmitz
Claudia Cucchi	Biba Schutz
Ursula Gnaedinger	Verena Sieber Fuchs
Gurhan	Marjorie Simon
Sophie Hanagarth	Jin-Sook So
Valerie Hector	Elena Spano
Anna Heindl	Claudia Stebler
Herman Hermsen	Dorothee Striffler
Yasuki Hiramatsu	Barbara Stutman
Meiri Ishida	Hye-Young Suh
Reiko Ishiyama	Tore Svensson
John Iversen	Janna Syvanoja
Hilde Janich	Salima Thakker
Alina Jay	Terhi Tolvanen
Karin Johansson	Henriette Tomasi
Ike Juenger	Martin Tomasi
Yeonmi Kang	Silke Trekel
Martin Kaufmann	Erik Urbschat
Ulla Kaufmann	Felieke van der Leest
Yael Krakowski	Peter Vermandere
Deborah Krupenia	Robean Visschers
Dongchun Lee	Karin Wagner
Stefano Marchetti	Jin-Soon Woo
Christine Matthias	Annamaria Zanella
Elisabeth McDevitt	Erich Zimmermann
Bruce Metcalf	

Ralph Bakker, Rings, *2003*
gold, South Sea pearl, silver oxidized, gold
photo: Karen Bell

Claire Curneen, St. Sebastian, *2003*
porcelain, 27h
photo: Dewi Tannatt Lloyd

Clay

Promoting the best of British ceramics
Staff: Charles Dimont; Cheryl Dimont; Sarah Edwards

226 Main Street
Venice, CA 90291
voice 310.230.9202
fax 301.230.9203
clayinla@earthlink.net

David Roberts, **Tall Vessels with Lines,** *2004*
ceramic, 24h

Representing:
Felicity Aylief
Jane Blackman
Sandy Brown
Robert Cooper
Claire Curneen
Steven Dixon
Gabriele Koch
Craig Mitchel
Frances Priest
David Roberts
Sarah Jane Selwood
Rupert Spira
Julian Stair
Janice Tchalenko
Takeshi Yasuda

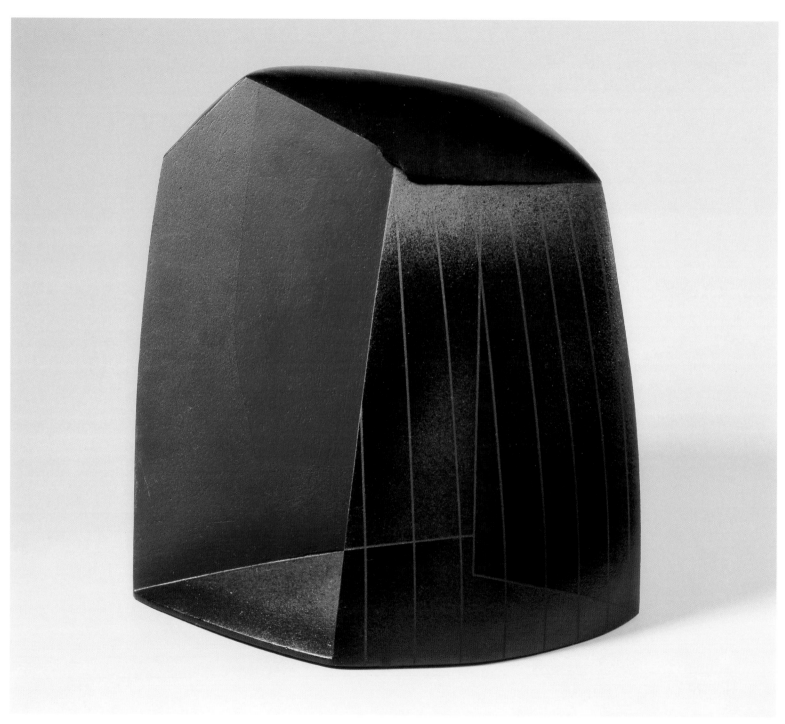

Yasuo Hayashi, **Prelude 98**
glazed stoneware, 13.5 x 13.5 x 15
photo: Alexandra Negoita

Dai Ichi Arts, Ltd.

Japanese ceramic art
Staff: Beatrice Lei Chang

249 East 48th Street
New York, NY 10017
voice 212.230.1680
fax 212.230.1618
daiichiarts@yahoo.com
daiichiarts.com

Representing:
Shoji Hamada
Yasuo Hayashi
Shigemasa Higashida
Kosuke Kaneshige
Tsubusa Katoh
Yuriko Matsuda
Harumi Nakashima
Goro Suzuki

Kosuke Kaneshige, **From the Sea,** *1999*
wood fired stoneware, 16 x 18 x 14
photo: Alexandra Negoita

Heide Kindelmann, **Compagnon** *brooch/pendant, 2003*
cast sterling silver, hand-painted and glazed with crocheted copper and gold wire, 3h

The David Collection

International fine arts with a specialty in contemporary studio jewelry
Staff: Jennifer David, director

44 Black Spring Road
Pound Ridge, NY 10576
voice 914.764.4674
fax 914.764.5274
jkdavid@optonline.net
thedavidcollection.com

Representing:
Mikiko Aoki
Tomomi Arata
Sara Bacsh
Beate Brinkmann
Barbara Christie
Carol DeBoth
Martina Dempf
Valerie Dubois
Nina Ehmck
Kyoko Fukuchi
Gill Galloway-
 Whitehead
Ursula Gnaedinger
Michael Good
Masako Hayashibe
Lydia Hirte
Kyung Shin Kim
Heide Kindelmann
Ingrid Larssen
Wilheim Tasso Mattar
Kathie Murphy
Suzanne Otwell Negre
Helge Ott
Maria Phillips
Alexandra Pimental
Sabine Reichert
Kayo Saito
Berthold Schwaiger
Larry Seegers
Kyoko Urino
Silvia Waltz

Michael Good, **Garland** *neckpiece, 2003*
bronze with rust colored patina, 10d
photo: Karen Bell

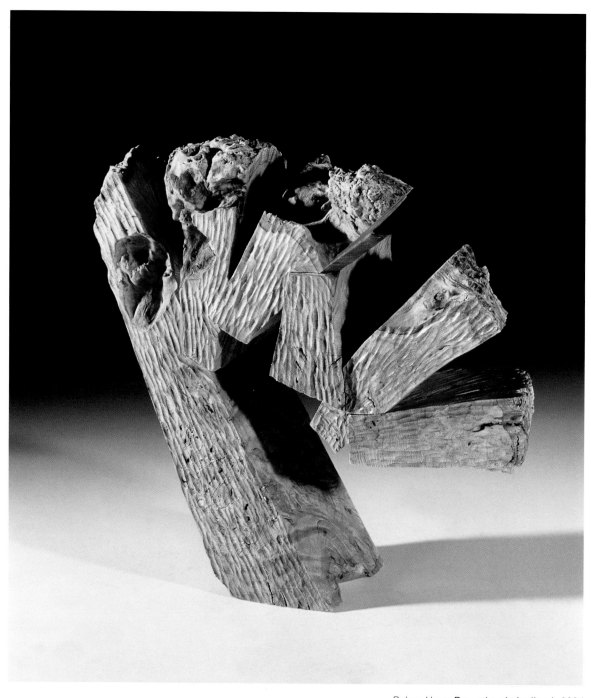

Robyn Horn, **Precariously Inclined,** *2004*
Tasmanian eucalyptus burl, 18 x 21 x 6
photo: Sean Moorman

del Mano Gallery

Turned and sculptured wood, fiber, and jewelry
Staff: Ray Leier; Jan Peters; Kirsten Muenster

11981 San Vicente Boulevard
Los Angeles, CA 90049
voice 310.476.8508
fax 310.471.0897
gallery@delmano.com
delmano.com

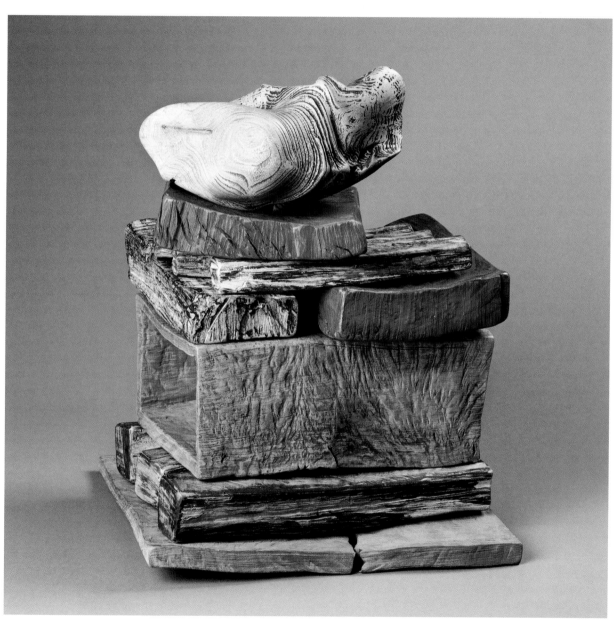

Representing:
Gianfranco Angelino
Christian Burchard
David Ellsworth
J. Paul Fennell
Ron Fleming
Louise Hibbert
Robyn Horn
John Jordan
Ron Kent
Stoney Lamar
Bud Latven
Philip Moulthrop
Sarah Parker-Eaton
Stephen Mark Paulsen
Michael Peterson
Binh Pho
Larissa Podgoretz
Vaughn Richmond
David Sengel
Michael Shuler
Fraser Smith
Ema Tanigaki
Jacques Vesery
Hans Weissflog

Michael Peterson, **Coastal Stack,** *2003*
pigmented, sand-blasted and bleached locust and madrone burl, 14.5 x 12 x 9
photo: Roger Schreiber

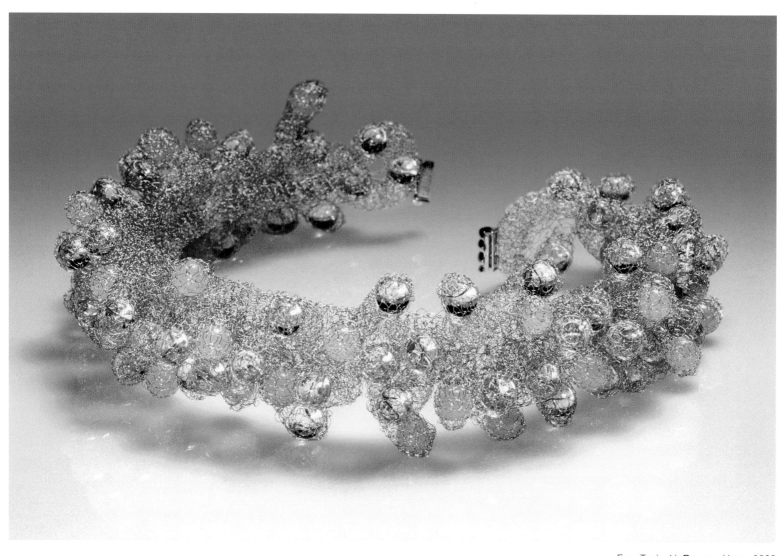

Ema Tanigaki, **Roe** *necklace, 2003*
hand crochet 24k gold plated stainless steel wire, crystal and rose quartz spheres, 15 length
photo: John L. Healey

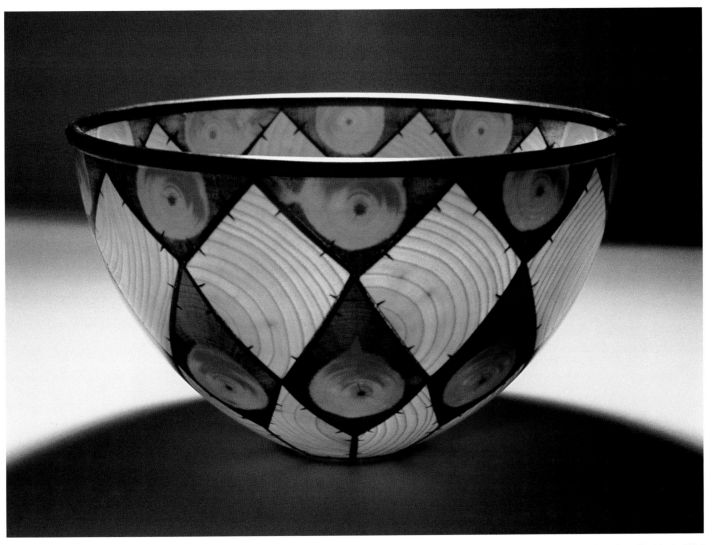

*Gianfranco Angelino, **Untitled**, 2004*
spalted pine, tree of heaven, cotton yarn, resin, 5.5 x 9.5
photo: Gianfranco Angelino

Michael Lucero, **Elf** *front view, 2003*
ceramic, embroidery, 30 x 24
photo: Eva Heyd

Donna Schneier Fine Arts

Modern masters in ceramics, glass, fiber, metal and wood
Staff: Donna Schneier; Leonard Goldberg; Jesse Sadia; Felix Esquivel

By Appointment Only
New York, NY
voice 212.472.9175
fax 212.472.6939
dnnaschneier@mhcable.com

Michael Lucero, **Elf** *back view, 2003*
ceramic, embroidery, 30 x 24
photo: Eva Heyd

Representing:
Jaroslava Brychtová
Wendell Castle
Dale Chihuly
Richard DeVore
Rick Dillingham
Stanislav Libenský
Harvey K. Littleton
Michael Lucero
Jim Makins
William Morris
Albert Paley
Ken Price
Mary Shaffer
Frantisek Vizner
Beatrice Wood
Betty Woodman

Sergei Isupov, **Ring of Fire,** *2004*
porcelain, 20 x 10 x 8
photo: Katherine Wetzel

Ferrin Gallery

Ceramic art and sculpture
Staff: Leslie Ferrin; Donald Clark; Michael McCarthy; Todd Clark

69 Church Street
Lenox, MA 01240
voice 413.637.4414
fax 914.271.0047
info@ferringallery.com
ferringallery.com

Representing:
Ilya Isupov
Sergei Isupov
Vladimir Isupov
Nelli Isupova

Ilya Isupov, **Fiance***, 1998*
watercolor on paper, 39 x 35

Joël Urruty, **Disk**, *2003*
mahogany, milk paint, 18 x 18 x 3

Finer Things Gallery

Wall constructions, studio furniture and sculpture
Staff: Kim Brooks, director

1898 Nolensville Road
Nashville, TN 37210
voice 615.244.3003
fax 615.254.1833
kkbrooks@bellsouth.net
finerthingsgallery.com

Representing:
Scott Grove
Sylvia Hyman
Charles Kegley
Tami Kegley
Guy Michaels
Brad Sells
Keizo Tsukada
Joël Urruty
Rusty Wolfe

Rusty Wolfe, **Unzipped,** *2003*
lacquer, MDF, wood, 96 x 48 x 7

Ken Price, **Evening Ware,** *1979*
glazed fired clay, 9 x 2.75 x 6.5

Franklin Parrasch Gallery

Contemporary art
Staff: Franklin Parrasch; Ian Pedigo; Kate Simon; Chris Churchill

20 West 57th Street
New York, NY 10019
voice 212.246.5360
fax 212.246.5391
info@franklinparrasch.com
franklinparrasch.com

Representing:
Robert Arneson
Lynda Benglis
John Cederquist
Stephen DeStaebler
John Mason
Beverly Mayeri
Ken Price
Elsa Rady
Rosanjin
Peter Voulkos
Betty Woodman

John Mason, **Blue Orbit,** *2004*
ceramic, 21 x 18 x 18
photo: Anthony Cunha

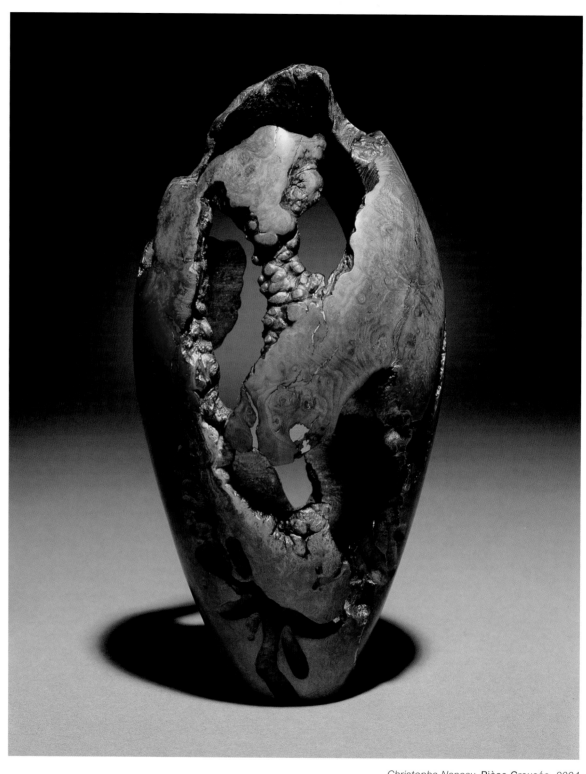

Christophe Nancey, **Pièce Creusée,** *2004*
manzanita, pewter, 17.3 x 7.9
photo: Roger Smith

Galerie Ateliers d'Art de France

Works by contemporary French artists in a variety of media
Staff: Marie-Armelle de Bouteiller; Anne-Laure Roussille

22 Avenue Niel
Paris 75017
France
voice 33.14.888.0658
fax 33.14.440.2368
galerie@ateliersdart.com
createdinfrance.com/artwork

Representing:
Martine Damas
Roland Daraspe
Jean-Louis Hurlin
Gladys Liez
Christophe Nancey
Nadia Pasquer

Jean-Louis Hurlin, **Lame Intérieure,** *2004*
Damascus steel, 5.9d
photo: Olivier Dancy

Gertraud Möhwald, **Head with Open Mouth,** *2001*
clay, shards, glazes, oxides, 14.75 x 17.5 x 17.5
photo: George Meister

Galerie b15–Renate Wunderle

Contemporary ceramic art: vessel, object and sculpture
Staff: Renate Wunderle; Bernhard Wunderle

Baaderstrasse 15
Munich D-80469
Germany
voice 49.89.202.1010
fax 49.89.642.1445
b15-wunderle@t-online.de
b15-wunderle.com

Representing:
Gordon Baldwin
Claude Champy
Monika Debus
Bernard Déjonghe
Jean-François
 Fouilhoux
Jean-Claude Legrand
Madola
Danae Mattes
Enrique Mestre
Gertraud Möhwald
Gilbert Portanier
Jean-Pierre Viot
Masamichi Yoshikawa

Madola, **Serie Urnes**, *2003*
stoneware, slips, oxides, 5 x 7 x 14.25
photo: Madola

Alain and Marisa Bégou, **Without Title,** *2003*
blown glass, 23 x 12.5 x 3.5
photo: M.A. Begou

Galerie Daniel Guidat

French gallery specializing in contemporary glass
Staff: Daniel Guidat, owner; Albert Feix, III, director

142 Rue d'Antibes
Cannes 06400
France
voice 33.49.394.3333
fax 33.49.394.3334
gdg@danielguidat.com
danielguidat.com

Czeslaw Zuber, **Head**, *2004*
optical glass, 16.5 x 10 x 9
photo: C. Zuber

Representing:
Fernando Agostinho
Alain Bégou
Francis Bégou
Marisa Bégou
Isabelle Emmerique
Yves Trucchi
Nad Vallee
Yan Zoritchak
Czeslaw Zuber

Susan Rankin, **Comfort**, *2003*
blown glass, steel wire, 14 x 13.5 x 13.5
photo: Trentphoto

Galerie Elena Lee

New directions of contemporary art glass for over 28 years
Staff: Elena Lee, president; Joanne Guimond, director; Cinzia Colella; Josée St-Onge; Sylvia Lee

1460 Sherbrooke West
Suite A
Montreal, Quebec H3G 1K4
Canada
voice 514.844.6009
fax 514.844.1335
info@galerieelenalee.com
galerieelenalee.com

Representing:
Annie Cantin
Brad Copping
Carole Frève
John Glendinning
Jeff Goodman
Susan Rankin
Cathy Strokowsky

Carole Frève, **Frimas: série des tempêtes,** *2003*
blown glass, thermoformed and electroplated, knit copper, glass beads, 15 x 12 x 6
photo: Michel Dubreuil

David Huycke, **Ovalinder 2** *vessel*
sterling silver, 7 x 5.5 x 4

Galerie Tactus

Contemporary European hollowware, wooden objects and a touch of jewelry
Staff: Lina and Peter Falkesgaard; Lisa Roemer

Gothersgade 54
Copenhagen 1123
Denmark
voice 45.33.933105
fax 45.35.431549
tactus@galerietactus.com
galerietactus.com

Representing:
Claus Bjerring
Sidsel Dorph-Jensen
Lina Falkesgaard
Torben Hardenberg
David Huycke
Martin Kaufmann
Ulla Kaufmann
Anders Lunderskov
Allan Scharff

Torben Hardenberg, **Thanatos** *clockwork
ebony and diamond briolet, 3 x 10 x 10
photo: Torsten Graae*

John Rose, **Hearing,** *2003*
poplar wood, 35 x 61 x 22

Gallery Materia

Established and emerging contemporary artists working in fiber, wood, clay, glass and metal

Staff: Michael Costello; Daryl Childs; Paul Booth

4222 North Marshall Way
Scottsdale, AZ 85251
voice 480.949.1262
fax 480.949.6050
gallery@gallerymateria.com
gallerymateria.com

Debra May, **Ocean's Flame**
glass, 8 x 17.5

Representing:
Roger Asay
Marian Bijlenga
Liz Franke
Keitaro Fujii
Tim Harding
Deborah Horrell
Jim Kraft
Debra May
Matt Moulthrop
Philip Moulthrop
Nancy Sansom
 Reynolds
Otto Rigan
John Rose
Carrie Seid
Tom Tuberty
Jason Walker

Richard Notkin, 20th Century Solutions Teapot: It Will Be The Same, *2003*
stoneware, 7.25 x 23
photo: Richard Notkin

Garth Clark Gallery

Modern and contemporary ceramic art

Staff: Garth Clark, president; Marsha Portiansky, assistant director; Mark Del Vecchio, director; Timothy Lomas, registrar; Osvaldo DaSilva, associate director, Claudio Rocha, conservator

24 West 57th Street, #305
New York, NY 10019
voice 212.246.2205
fax 212.489.5168
mark@garthclark.com
garthclark.com

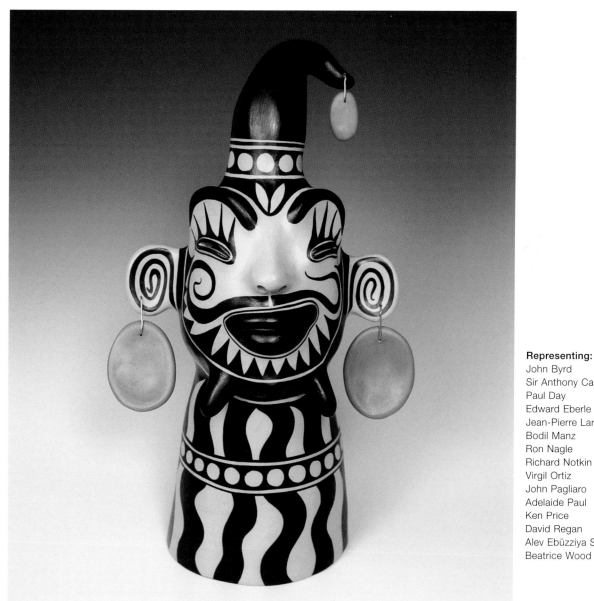

Representing:
John Byrd
Sir Anthony Caro
Paul Day
Edward Eberle
Jean-Pierre Larocque
Bodil Manz
Ron Nagle
Richard Notkin
Virgil Ortiz
John Pagliaro
Adelaide Paul
Ken Price
David Regan
Alev Ebüzziya Siesbye
Beatrice Wood

Virgil Ortiz, **Untitled Figurine***, 2003*
Conchiti red clay, 16 x 11

Nicholas Arroyave-Portela, **Tall Cut Wave Form**
glazed ceramic, 20 x 6.5

Helen Drutt: Philadelphia

Established in 1973-74, Helen Drutt: Philadelphia though, committed to all aspects of the field, specializes in ceramic arts and contemporary jewelry

Staff: Helen W. Drutt English, founder/director; Hurong Lou, assistant director; Martha Flood, archivist

By Appointment Only
2220-22 Rittenhouse Square
Philadelphia, PA 19103-5505
voice 215.735.1625
fax 215.732.1382

Contemporary Jewelry: In Philadelphia
Robert Baines
Gijs Bakker
Manfred Bischoff
Pierre Cavalan
Peter Chang
Sharon Church
Georg Dobler
Kyoko Fukuchi
Thomas Gentille
Hermann Jünger
Betsy King
Carlier Makigawa
Bruno Martinazzi
Falko Marx
Bruce Metcalf
Breon O'Casey
Ritsuko Ogura
Judy Onofrio
Kim Overstreet/
 Robin Kranitzky
Francesco Pavan
Ramon Puig Cuyas
Gerd Rothmann
Bernhard Schobinger
Deganit Schocken
Helen Shirk
Peter Skubic
Tore Svensson
Merrily Tompkins
Tone Vigeland
Margaret West
Nancy Worden

Ceramics:
Nicholas Arroyave-
 Portela
Jill Bonovitz
Nancy Carman
Anne Currier
William Daley
Wayne Higby
Luo Xiaoping
Rudolf Staffel
Lizbeth Stewart
Robert Turner
Paula Winokur
Robert Winokur
Sun Koo Yuh

Textiles:
Risë Nagin

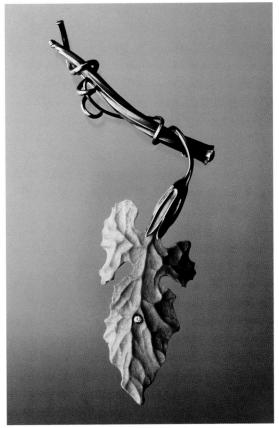

Sharon Church, **Snake Leaf Brooch,** *1999*
oxidized sterling silver, antler, old European cut diamonds, 4.5 x 3 x .5

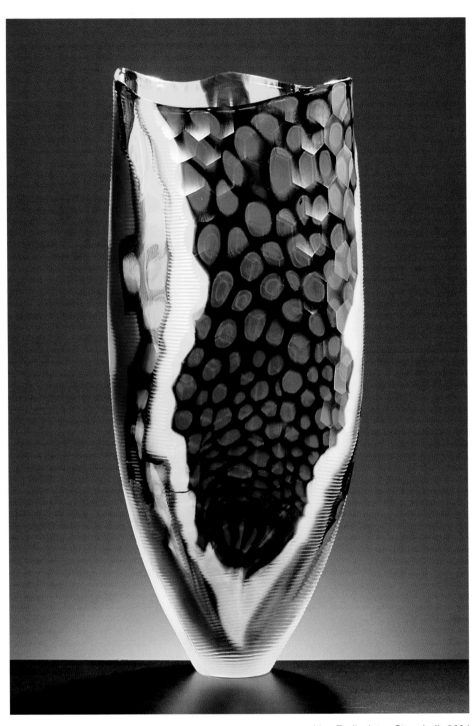

Lino Tagliapietra, **Stromboli,** *2004*
glass, 19.5 x 8.75 x 6.5
photo: Russell Johnson

Heller Gallery

Celebrating 30 years exhibiting sculpture using glass as a fine art medium
Staff: Douglas Heller; Katya Heller; Michael Heller; Margaretha Murphy; Bob Roberts

420 West 14th Street
New York, NY 10014
voice 212.414.4014
fax 212.414.2636
info@hellergallery.com
hellergallery.com

Representing:
Hank Adams
Nicole Chesney
Karen LaMonte
Lino Tagliapietra

Lino Tagliapietra, **Mandara,** *2003*
glass, 15.75 x 14.25 x 6.5
photo: Russell Johnson

Dante Marioni, **Vessel Display,** *2004*
blown glass with wood box, 27 x 19 x 5
photo: Roger Schreiber

Holsten Galleries

Contemporary glass art

Staff: Kenn Holsten, owner; Jim Schantz, director; Mary Childs, associate director; Joe Rogers

3 Elm Street
Stockbridge, MA 01262
voice 413.298.3044
fax 413.298.3275
artglass@holstengalleries.com
holstengalleries.com

Representing:
Dante Marioni
Stephen Rolfe Powell
Martin Rosol

Stephen Rolfe Powell, **Pouncing Crimson Dogma**, *2003*
blown glass, 20.25 x 27.5 x 10.5
photo: Stephen Powell

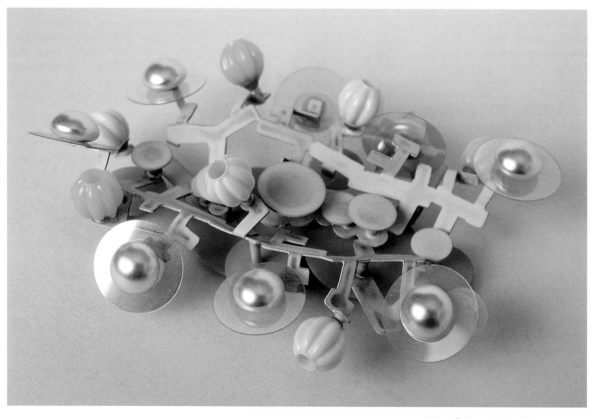

Helen Britton, **Valley Brooch,** *2003*
silver, plastics, glass, paint, 4 x 3 x 1

Jewelers' Werk Galerie

New jewelry from international artists
Staff: Ellen Reiben, director

2000 Pennsylvania Avenue NW
Washington, DC 20006
voice 202.293.0249
fax 202.659.4149
ellenreiben@earthlink.net

Doris Betz, **Brooch,** *2003*
silver, pyrite dust, 3.5 x 3 x .25

Representing:

Alexandra Bahlmann	Christa Lühtje
Peter Bauhuis	Sally Marsland
Doris Betz	Yutaka Minegishi
David Bielander	Darcy Miro
Iris Bodemer	Valerie Mitchell
Helen Britton	Ruudt Peters
Cynthia Cousens	Shari Pierce
Bettina Dittlmann	Karen Pontoppidan
Xavier Domenech	Mary Preston
Mason Douglas	Dorothea Prühl
Sophia Epp	Mah Rana
Warwick Freeman	Alexandra Rivera
Karl Fritsch	Dorothea Schippel
Thomas Gentille	Margrit Schneeweiss
Mielle Harvey	Barbara Seidenath
Angela Hübel	Jiří Šibor
Mari Ishikawa	Vera Siemund
John Iversen	Bettina Speckner
Michael Jank	Didi Suydam
Svenja John	Tore Svenson
Hermann Jünger	Rachelle Thiewes
Martin Kaufmann	Agnes von Rimscha
Ulla Kaufmann	Anuschka Walch
Otto Künzli	Lisa Walker
Seung-Hea Lee	Ginny Whitney
Walli Lieglein	Andrea Wippermann

Morino Hiroaki Taimei, **Kabuki,** *2003*
stoneware vessel with red and black iron-oxide glazes, 7.5 x 8.6 x 6.5
photo: Takashi Hatakeyama

Joan B. Mirviss, Ltd.

Fine Japanese ceramics by modern masters and contemporary talents
Staff: Joan B. Mirviss; Nadine Welch

PO Box 231095
Ansonia Station
New York, NY 10023
voice 212.799.4021
fax 212.721.5148
joan@mirviss.com
mirviss.com

Representing:
Shoji Hamada
Shoji Kamoda
Masanao Kaneta
Shinobu Kawase
Junko Kitamura
Shoko Koike
Michio Koinuma
Takahiro Kondo
Seiko Minegishi
Zenji Miyashita
Togaku Mori
Taimei Morino
Takuo Nakamura
Kitaôji Rosanjin
Takayuki Sakiyama

Kitaôji Rosanjin, **Shino White Glazed Square Plate with Red Strokes,** *c.1950*
stoneware, white shino and iron-oxide red glazes, 2.75 x 11.75 x 11.75
photo: Richard Goodbody

Gerald Heffernon, **Exotic Shortpile,** *2002*
mixed media, carpet, 15 x 20 x 10
photo: Tony Novelozo

John Natsoulas Gallery

Northern California contemporary art and ceramic sculpture
Staff: John Natsoulas, owner; Steve Rosenzweig, marketing director

521 First Street
Davis, CA 95616
voice 530.756.3938
fax 530.756.3961
art@natsoulas.com
natsoulas.com

Representing:
Robert Arneson
Camille Claudel
Roy De Forest
Gerald Heffernon
Esther Shimazu
Hassel Smith
Peter VandenBerge

Camille Claudel, **Study for Avarice and Lust,** *1883*
bronze, 5.75 x 4 x 4
photo: Artists Rights Society

Susan Beiner, **Harlequin,** *2003*
porcelain, 19 x 11 x 10.5
photo: Al Karevy

Lacoste Gallery

Contemporary ceramics relating to the vessel and sculptural form
Staff: Lucy Lacoste; Linda Lofaro; Johanna Gluck

25 Main Street
Concord, MA 01742
voice 978.369.0278
fax 978.369.3375
lacoste@gis.net
lacostegallery.com

Representing:
Susan Beiner
Pascal Chmelar
Michelle Erickson
Randy Johnston
Connie Kiener
Keisuke Mizuno
Mark Pharis
Betsy Rosenmiller
Tim Rowan
Bonnie Seeman
Mark Shapiro
Diana Thomas
Christine Viennet
Maryann Webster

Mark Pharis, **Oval Tray**, *2004*
earthenware, 8 x 28 x 6
photo: Peter Lee

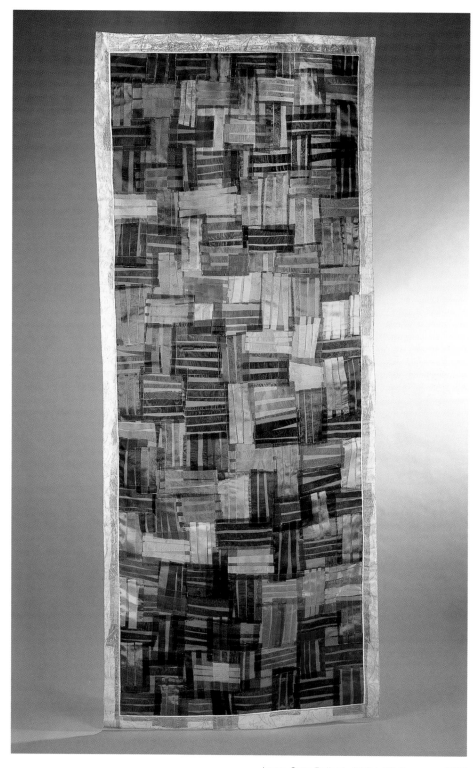

Junco Sato Pollack, **KESA #7 Sansara**, *2002*
printed and pieced polyester organza, 103 x 43

Lea Sneider

Contemporary fiber art and ceramics from Japan and Korea
Staff: Lea Sneider; Eleanor S. Hyun

211 Central Park West
New York, NY 10024
voice 212.724.6171
fax 212.769.3156
learsneider@aol.com

Representing:
Tetsuo Fujimoto
Sueharu Fukami
Shoichi Ida
Shigeo Kubota
Tetsuo Kusama
Chunghie Lee
Junco Sato Pollack
Naoko Serino
Sang Ho Shin
Jin-Sook So
Junko Suzuki
Hideho Tanaka
Kazuko Yamanaka

*Kazuko Yamanaka, **Golden Globe**, 2002*
crocheted stainless steel, brass and copper wire, 10d
photo: Adam Thorman

KéKé Cribbs, **Say What? Bird Pot,** *2004*
porcelain, glass, copper, gold leaf, 25 x 11 x 6.5
photo: Robert Vinnedge

Leo Kaplan Modern

Established artists in contemporary glass sculpture and studio art furniture
Staff: Scott Jacobson; Terry Davidson; Lynn Leff; Courtney Fox

41 East 57th Street
7th floor
New York, NY 10022
voice 212.872.1616
fax 212.872.1617
lkm@lkmodern.com

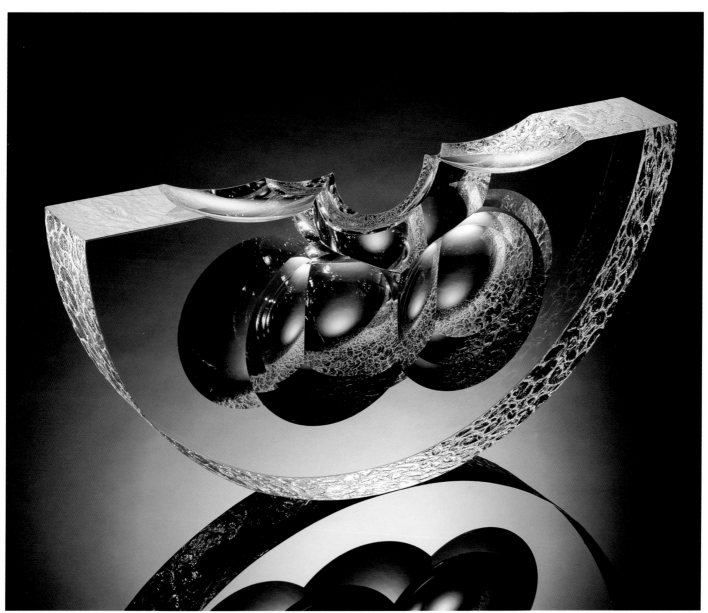

Steven Weinberg, **Quonochtaug Pond Boat,** *2004*
cast crystal, 11 x 23 x 4
photo: Marty Doyle

Representing:
Garry Knox Bennett
Greg Bloomfield
Yves Boucard
William Carlson
Wendell Castle
José Chardiet
Scott Chaseling
KéKé Cribbs
Dan Dailey
David Huchthausen
Richard Jolley
Kreg Kallenberger
John Lewis
Thomas Loeser
Linda MacNeil
Paul Seide
Tommy Simpson
Jay Stanger
Michael Taylor
Cappy Thompson
Gianni Toso
Mary Van Cline
Steven Weinberg
Ed Zucca

Ole Lislerud, **Scream,** *2003*
porcelain, 35.5 x 35.5

Loveed Fine Arts

Contemporary ceramic works of art

Staff: Edward R. Roberts, president; Daniel Hamparsumyan, Ronald A. Kuchta, Nancy C. Roberts, directors

575 Madison Avenue
Suite 1006
New York, NY 10022-2511
voice 212.605.0591
fax 212.605.0592
loveedfinearts@earthlink.net
loveedfinearts.com

Margie Hughto, **Primordial Sunset,** *2002*
glazed ceramic, mixed media, 51.5 x 43 x 5
photo: Eva Heyd

Representing:
Susan Budge
Nino Caruso
Tom Folino
Margie Hughto
Yih-Wen Kuo
Marc Leuthold
Ole Lislerud
Nancy Lovendahl
Sylvia Nagy
Gilda Oliver
Mary Suh
Xavier Toubes
Rouska Valkoua
Patti Warashina

Jon Kuhn, **Pure Reason,** *2003*
laminated glass, 15 x 12 x 5.5
photo: Jackson Smith

Marx-Saunders Gallery, Ltd.

The most innovative and important artists working in glass in the world
Staff: Bonita Marx and Ken Saunders, directors; Donna Davies; Dan Miller; James Geisen

230 West Superior Street
Chicago, IL 60610
voice 312.573.1400
fax 312.573.0575
marxsaunders@earthlink.net
marxsaunders.com

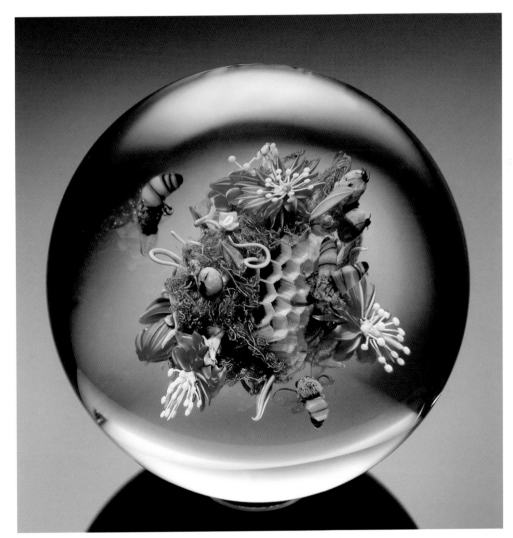

Representing:
William Carlson
José Chardiet
Sidney Hutter
Jon Kuhn
Joel Philip Myers
Mark Peiser
Richard Ritter
Thomas Scoon
Paul Stankard
Lisabeth Sterling
Janusz Walentynowicz

Paul Stankard, Pineland Pickerel Weed Orb with Honeycomb and Honeybees, *2003*
lampworked glass, 5 x 5 x 5
photo: Douglas Schaible

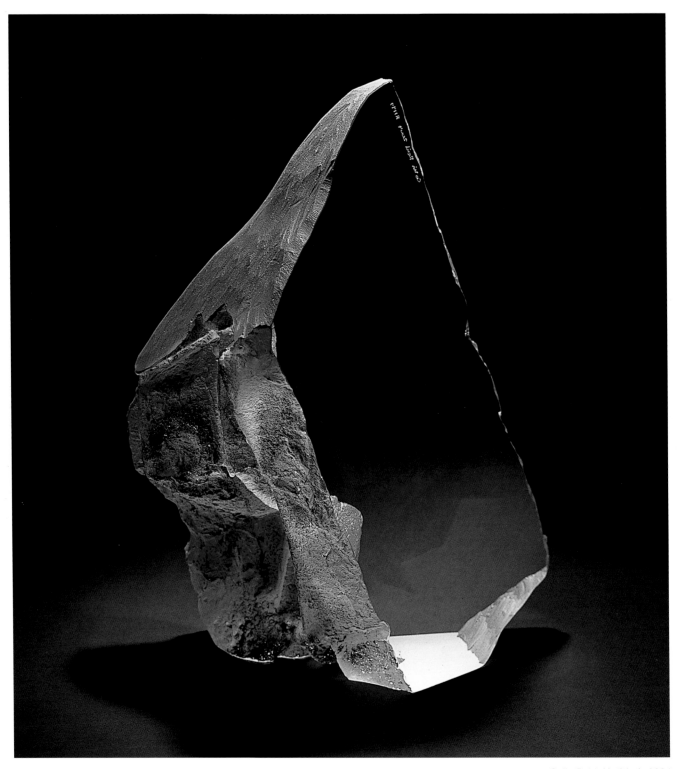

Colin Reid, **Untitled,** *2004*
glass, 16.5 x 13 x 6.75

Maurine Littleton Gallery

Sculptural work of contemporary masters in glass
Staff: Maurine Littleton, director; Susan Apollonio; Seth Campbell; Zach Vaughn

1667 Wisconsin Avenue NW
Washington, DC 20007
voice 202.333.9307
fax 202.342.2004
littletongallery@aol.com

John Littleton & Kate Vogel, **Our Gem**, 2004
hot-worked, cut and polished cast glass, 18 x 8 x 5.5
photo: John Littleton

Representing:
Harvey K. Littleton
John Littleton
Colin Reid
Therman Statom
Kate Vogel

Suzan Rezac, vitis amabilis, *2004*
oxidized silver, 18k gold, 30 x 1.75 x .5
photo: Tom Van Eynde

Mobilia Gallery

Decorative arts of the 20th and 21st century featuring studio jewelry, textiles, studio furniture, ceramics
Staff: Libby Cooper; JoAnne Cooper; Susan Cooper

358 Huron Avenue
Cambridge, MA 02138
voice 617.876.2109
fax 617.876.2110
mobiliaart@aol.com
mobilia-gallery.com

Representing:

Renie Breskin Adams	Elizabeth McDevitt
Tomomi Arata	John McQueen
Donna Barry	Nancy Michel
Linda Behar	Kazuko Mitsushima
Hanne Behrens	Harold O'Connor
Flora Book	Joan Parcher
Michael Boyd	Sarah Perkins
David K. Chatt	Gugger Petter
Kirsten Clausager	Giovanna Quadri
Kevin Coates	Robin Quigley
Jim Cole	Gerri Rachins
Susan Cross	Anette Rack
Jack da Silva	Wendy Ramshaw,
Marilyn da Silva	OBE RDI
Siegfried DeBuck	Kim Rawdin
Linda Dolack	Todd Reed
Dorothy Feibleman	Suzan Rezac
Arline Fisch	Carme Roher-Casellas
Gerda Flockinger, CBE	Ed Rossbach
David Freda	Scott Rothstein
Elizabeth Fritsch, CBE	Axel Russmeyer
Emi Fujita	Yuka Saito
John Garrett	Marjorie Schick
Mielle Harvey	Joyce J. Scott
Makoto Hieda	Richard Shaw
Nick Hollibaugh	Christina Smith
Mary Lee Hu	Etsuko Sonobe
Dan Jocz	Jennifer Trask
Rosita Johanson	Andrea Uravitch
Rena Koopman	Graziano Visintin
Okinari Kurokawa	Alexandra Watkins
Mariko Kusumoto	Claude Wesel
Fritz Maierhofer	Katherine Westphal
Donna Rhae Marder	Joe Wood
Tomomi Maruyama	Mizuko Yamada
Alphonse Mattia	Yoshiko Yamamoto

Renie Breskin Adams, **Professor of Vegimals**, *2004*
cotton embroidery, 6.5 x 8.5

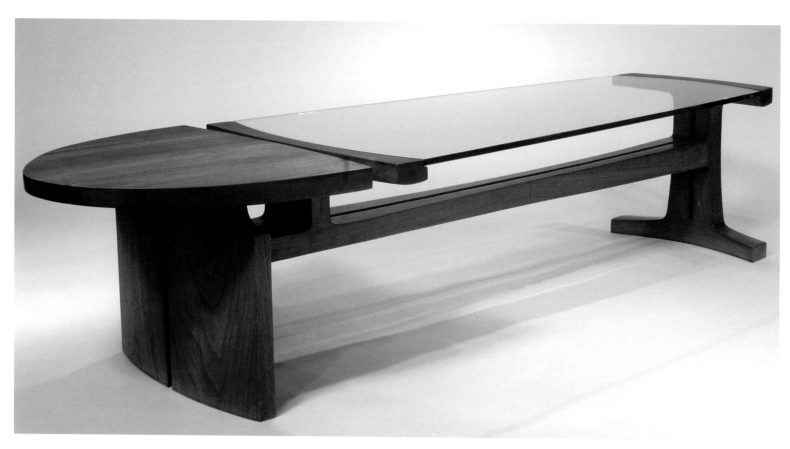

Daniel Jackson, **Coffee Table,** *1974*
American black walnut, glass, 16 x 71 x 24
photo: Michael J. Joniec

Moderne Gallery

Vintage works from the American Craft and Studio Furniture Movement, 1920-2000
Staff: Robert Aibel, owner/director; Michael Gruber, designer; Cynthia Tyng, manager

111 North 3rd Street
Philadelphia, PA 19106
voice 215.923.8536
fax 215.923.8435
raibel@aol.com
modernegallery.com

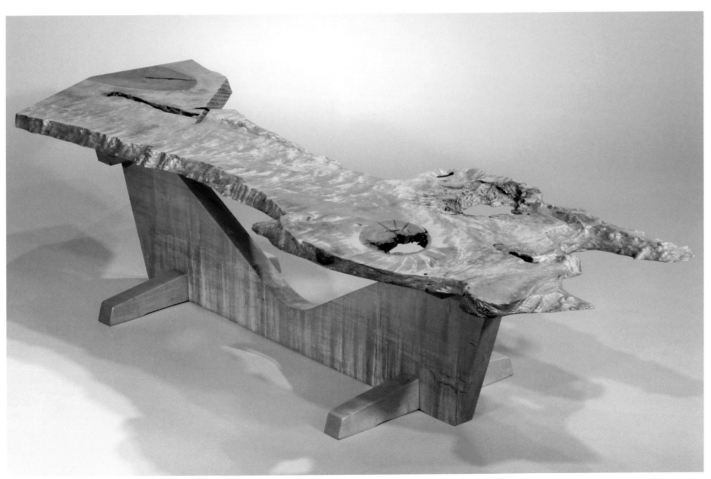

Representing:
Wendell Castle
David Ebner
Wharton Esherick
Ken Ferguson
Maija Grotell
Daniel Jackson
Karen Karnes
Sam Maloof
Alphonse Mattia
Leza McVey
Ed Moulthrop
George Nakashima
Mira Nakashima
Rude Osolnik
James Prestini
David Roth
Hap Sakwa
Bob Stocksdale
Toshiko Takaezu
Peter Voulkos

George Nakashima, **Coffee Table***, 1973*
curly maple, 14 x 65 x 21
photo: Michael J. Joniec

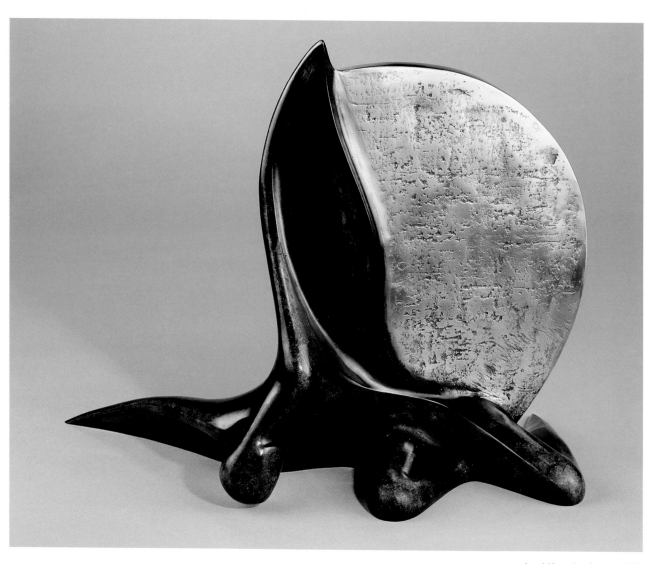

Loni Kreuder, **Icare***, 1999*
bronze sculpture, 16 x 20 x 9

Modus Gallery

Modern and contemporary art; glass and bronze sculpture
Staff: Karl Yeya, Gabriel Eid; Mana Asselli; Richard Elmir

23 Place des Vosges
Paris 75003
France
voice 33.14.278.1010
fax 33.14.278.1400
modus@noos.fr
galerie-modus.com

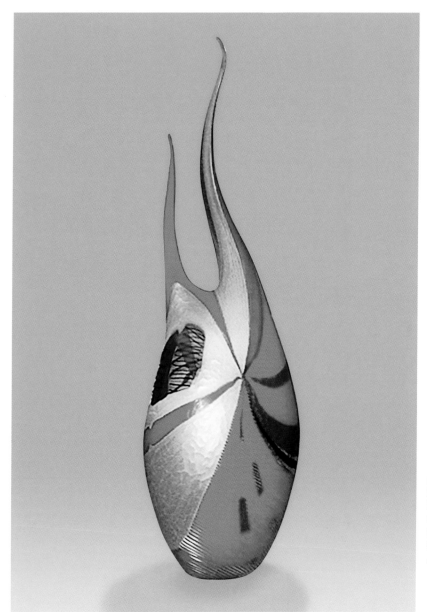

Representing:
Françoise Abraham
Leon Bronstein
Dominique Dardek
Ray Howelett
Loni Kreuder
Mourosso
Alain Salomon

Renato Trevisan, **Duo,** *2004*
glass, 24.8 h

Iwao Matsushima, **Spinning Cone with Beads,** *2004*
Core forming glass, 17 x 8
photo: I. Matsushima

Mostly Glass Gallery

Innovative art that is aesthetically appealing and technically challenging
Staff: Sami Harawi; Charles Reinhardt

3 East Palisade Avenue
Englewood, NJ 07631
voice 201.816.1222
fax 201.816.9582
info@mostlyglass.com
mostlyglass.com

Representing:
Vittorio Costantini
Antonio Dei Rossi
Mario Dei Rossi
Miriam Di Fiore
Iwao Matsushima
Alison Ruzsa

Miriam Di Fiore, **Pioppaia Verde,** *2002*
glass, 17 x 40 x 14
photo: Eva Heyd

129

Jack Earl, **Stoneman Smiling,** *2003*
ceramic, oil paint, 31 x 24 x 10

Nancy Margolis Gallery

Contemporary ceramics and fiber
Staff: Eun Joo Won, assistant to director; Nancy Margolis, director

523 West 25th Street
New York, NY 10001
voice 212.242.3013
fax 212.242.4087
nancymargolisgallery.com

Representing:
Karen Bennicke
Lia Cook
Barbara Diduk
Jack Earl
Steven Heinemann
Eva Hild
Lissa Hunter
Ferne Jacobs
Jiansheng Li
Marit Tingleff
Tip Toland
Arnold Zimmerman

Eva Hild, **The Breaking-up Series,** *2002*
stoneware, ceramic, 24 x 33.5 x 33.5
photo: Andrea Björsell

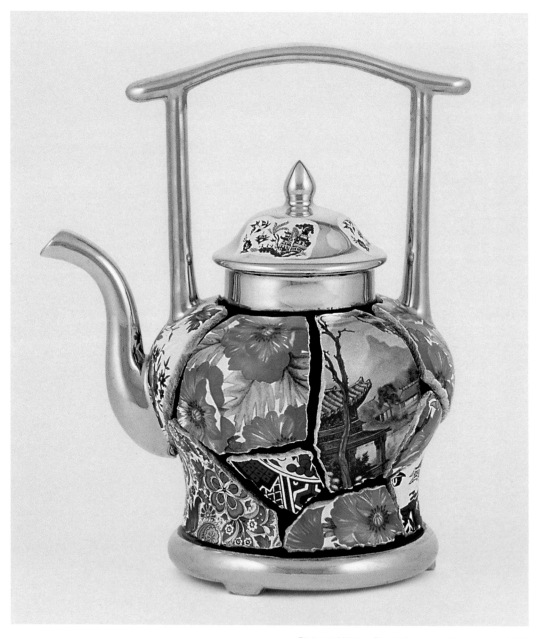

Richard Milette, **Shard Teapot with Poppies,** *2002*
ceramic, 11 x 8.5 x 6.5
photo: Richard Milette

Option Art

Excellence in Canadian art furniture, jewelry, ceramics, fiber and glass
Staff: Barbara Silverberg, director; Dale Barrett, assistant

4216 de Maisonneuve Blvd. West
Suite 302
Montreal, Quebec H3Z 1K4
Canada
voice 514.932.3987
fax 514.932.6182
info@option-art.ca
option-art.ca

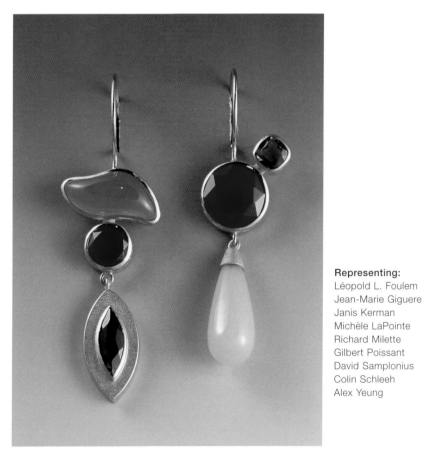

Representing:
Léopold L. Foulem
Jean-Marie Giguere
Janis Kerman
Michèle LaPointe
Richard Milette
Gilbert Poissant
David Samplonius
Colin Schleeh
Alex Yeung

Janis Kerman, **Earrings**, *2004*
18k gold, iolite, carnelian, blue chalcedony

Bahram Shabahang, **Kashkooli Galaxy,** *2003*
wool foundation, wool pile Persian carpet, 120 x 156

Orley Shabahang

The finest antique and contemporary Persian carpets the world has to offer
Staff: Bahram Shabahang; Geoffrey A. Orley; Zsolt Enzsol

240 South County Road
Palm Beach, FL 33480
voice 561.655.3371
geoffreyorley@aol.com
shabahangcarpets.com

Representing:
Bahram Shabahang

Bahram Shabahang, **Kashkooli Garden Design,** *2002*
wool foundation, wool pile Persian carpet, 84 x 120

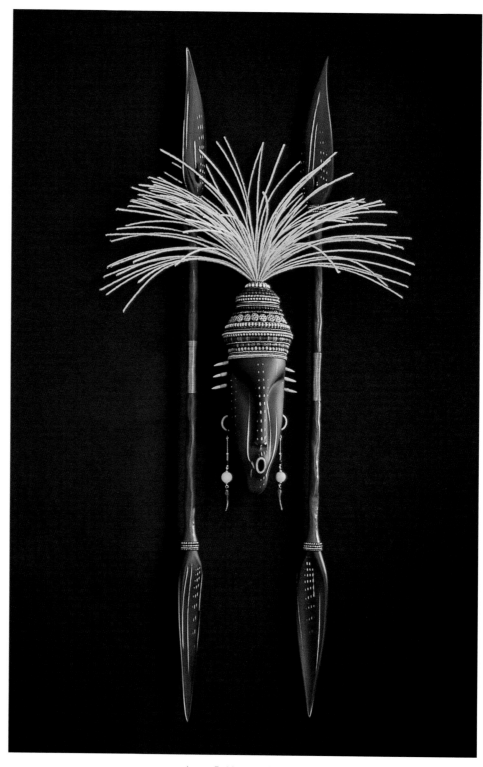

Jenny Pohlman & Sabrina Knowles, **Minerva; Man As Art,** *2004*
blown and hot-sculpted glass, found objects, steel, 67 x 28 x 18
photo: Russell Johnson

R. Duane Reed

Contemporary painting, glass, ceramics, fiber and mixed media
Staff: R. Duane Reed; Merrill Strauss; Glenn Scrivner; Kate Anderson

711 East Las Olas
Boulevard
Fort Lauderdale, FL 33301
voice 954.525.5210
fax 954.525.5206
flareedart@primary.net

7513 Forsyth Boulevard
St. Louis, MO 63105
voice 314.862.2333
fax 314.862.8557
reedart@primary.net
rduanereedgallery.com

Representing:
Dorothy Hafner
Sabrina Knowles
Jenny Pohlman
Ross Richmond

Dorothy Hafner, **Colorways,** *2003*
suite of four fused glass panels, stainless steel, 17 x 79 x 5
photo: George Erml

Tina Rath, **Black Beauty Collar,** *2003*
fox, ebony, leather, 18k gold
photo: Kevin Sprague

Sienna Gallery

International contemporary jewelry
Staff: Sienna Patti; Sherida Lincoln; Raissa Bump

80 Main Street
Lenox, MA 01240
voice 413.637.8386
fax 413.637.8387
info@siennagallery.com
siennagallery.com

Representing:
Giampaolo Babetto
Jamie Bennett
Lola Brooks
Noam Elyashiv
Donald Friedlich
Stephanie Jendis
Esther Knobel
Alyssa Dee Krauss
Seung-Hea Lee
Jacqueline Lillie
Tina Rath
Barbara Seidenath
Sondra Sherman
Bettina Speckner
Johan van Aswegen

Giampaolo Babetto, **Earclip,** *2003*
white gold, Plexiglas
photo: Kevin Sprague

Jon Eric Riis, **Black & White,** *2003*
tapestry woven silk, freshwater pearls, leather, 32 x 69

Snyderman-Works Galleries

Cutting-edge contemporary studio ceramics, fiber, jewelry, furniture, glass, painting and sculpture;
special presentation at SOFA NEW YORK: Fresh Air from Korea, *curated by Kiwon Wang*
Staff: Rick and Ruth Snyderman, owners; Bruce Hoffman, director; Frances Hopson, assistant director;
Jen McCartney, associate; Leor Sabbah, sales

303 Cherry Street
Philadelphia, PA 19106
voice 215.238.9576
fax 215.238.9351
bruce@snyderman-works.com
snyderman-works.com

Dallae Kang, **Greetings** *necklace, 2002*
sterling silver, colored plastics, 8 x 16 x 16

Representing:
Karin Birch
Yvonne Pacanowsky
 Bobrowicz
Joyce Crain
Kiyomi Iwata
Ritzi Jacobi
Dallae Kang
Ed Bing Lee
Ke-sook Lee
Jon Eric Riis
Joyce J. Scott
Byung-Joo Suh
Kiwon Wang
Deborah Warner
Kathy Wegman
Tom Wegman
Noriko Yamaguchi
Soonran Youn

Honda Syoryu, **Time Cycle,** *2003*
bamboo, 12.5 x 17 x 13
photo: Carolyn Wright

Tai Gallery/Textile Arts

Japanese bamboo arts and museum quality textiles from Africa, India, Indonesia, and Japan
Staff: Robert T. Coffland; Mary Hunt Kahlenberg; Marybeth Welch

616 1/2 Canyon Road
Santa Fe, NM 87501
voice 505.983. 9780
fax 505.989.7770
gallery@textilearts.com
textilearts.com

Representing:
Abe Motoshi
Fujinuma Noboru
Hatakeyama Seido
Honda Syoryu
Honma Hideaki
Katsushiro Soho
Kawano Shoko
Kawashima Shigeo
Monden Yuichi
Morigami Jin
Nagakura Kenichi
Sugita Jozan
Tanaka Kyokusho
Torii Ippo
Yamaguchi Ryuun

Nagakura Kenichi, **Star Dust,** *2003*
bamboo, 17.5 x 19 x 10
photo: Carolyn Wright

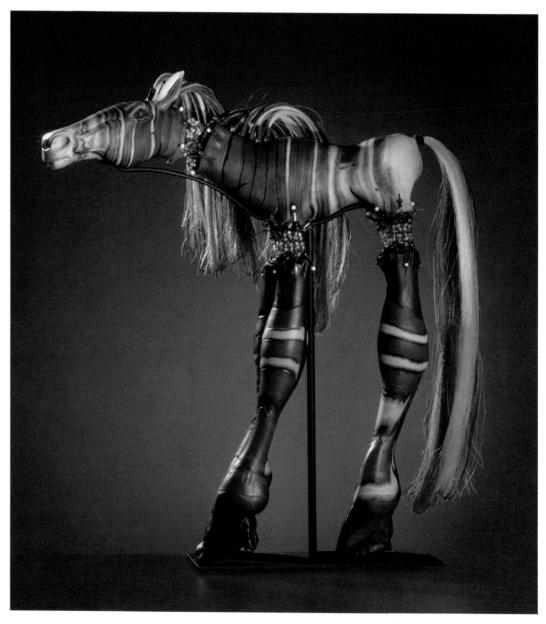

Shelley Muzylowski-Allen, **Arion**
blown glass, 27.5 x 24 x 6
photo: Russell Johnson

Thomas R. Riley Galleries

Timeless three-dimensional forms with strong aesthetic content
Staff: Cindy and Tom Riley, owners; Cheri Discenzo, director, Cleveland

2026 Murray Hill Road
Cleveland, OH 44106
voice 216.421.1445
fax 216.421.1435
clevelandinfo@rileygalleries.com

642 North High Street
Columbus, OH 43215
voice 614.228.6554
fax 614.228.6550
columbusinfo@rileygalleries.com
rileygalleries.com

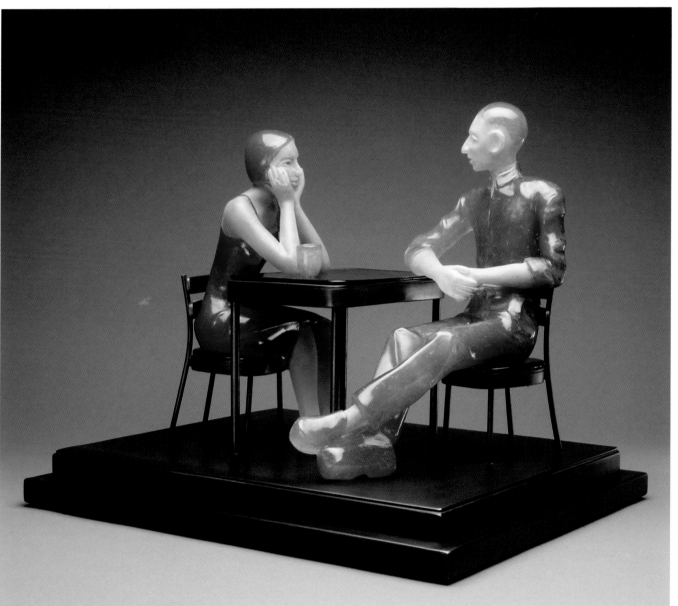

Representing:
David Bennett
Latchezar Boyadjiev
Don Charles
Deanna Clayton
Keith Clayton
Kyohei Fujita
Hitoshi Kakizaki
Lucy Lyon
Duncan McClellan
Shelley Muzylowski-Allen
Marc Petrovic
Seth Randal
Mel Rea
David Reekie
Joseph Rossano
Kari Russell-Pool
Karen Willenbrink-
 Johnsen
Hiroshi Yamano

Lucy Lyon, **9 AM,** *2003*
cast glass, 16 x 21 x 17

145

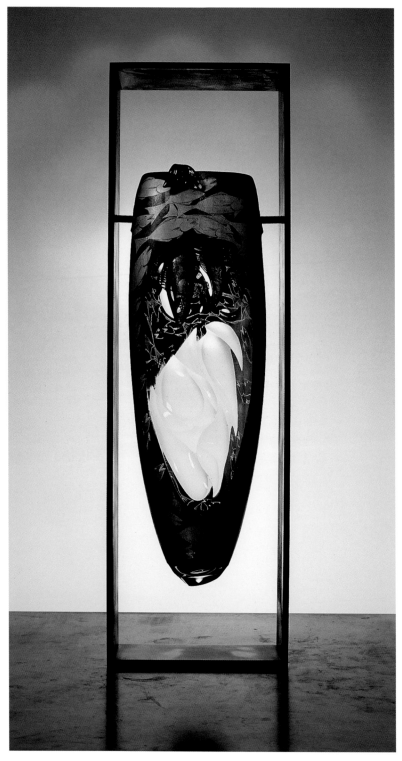

Hiroshi Yamano, **Fish Hanger #27,** *2003*
blown and sculpted glass with silver leaf drawing and electroplating, steel stand, 39 x 10 x 4

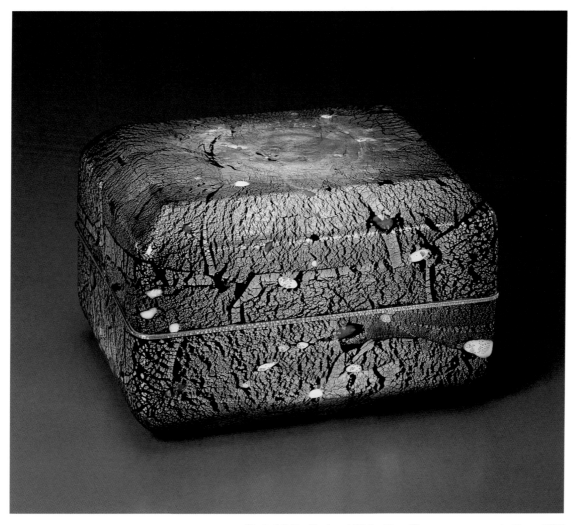

Kyohei Fujita, **Red and White Plum Blossoms** *ornamented box, 1995*
18.5 x 30 x 24

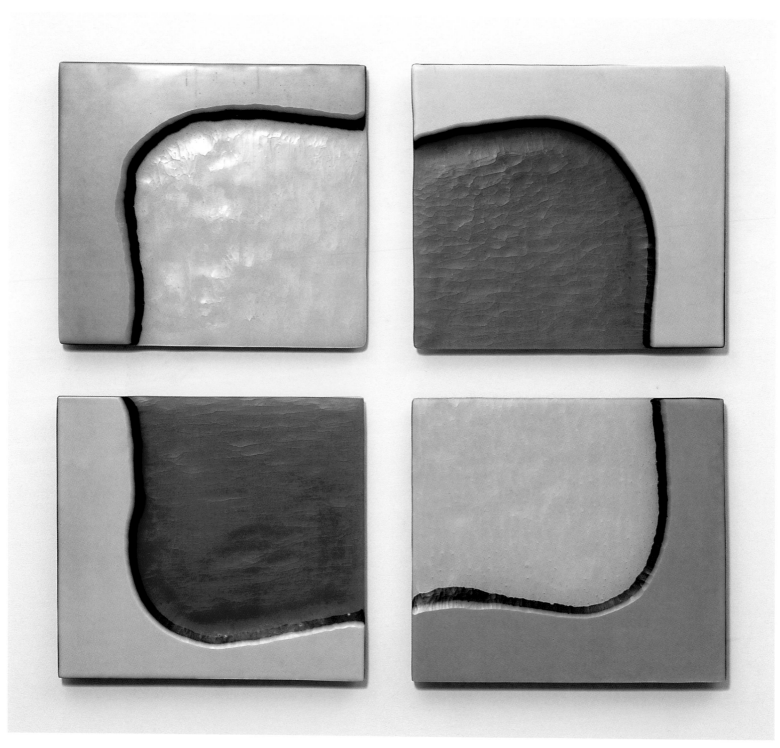

Jamie Harris, **Landscape,** *2003*
fused and carved glass, 40 x 40 x 3
photo: D. James Dee

UrbanGlass New York Contemporary Glass Center

An international center for new art made from glass
Staff: Dawn Bennett, executive director; Brooke Benaroya, development officer

647 Fulton Street
Brooklyn, NY 11217-1112
voice 718.625.3685
fax 718.625.3889
info@urbanglass.org
urbanglass.org

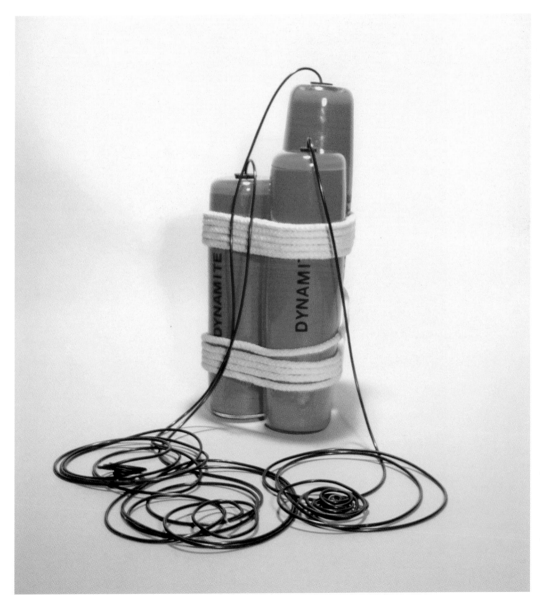

Deborah Adler, Dynamite, *2003
glass, paint, rubber, rope, 14 x 10 x 10*

Stephen Knapp, **Blue Surround**, *2003*
light, glass, stainless steel on panel, 44 x 32 x 10
photo: Stephen Knapp

Walker Fine Art

Modern and contemporary sculpture featuring new paintings in light
Staff: Rock J. Walker; Stephen Knapp

478 West Broadway
New York, NY 10012
voice 347.563.2100
fax 646.840.9999
rockartusa@msn.com
lightpaintings.com

Representing:
Stephen Knapp

Stephen Knapp, **Cityscape**, *2003*
light, glass, stainless steel on panel, 36 x 24 x 10
photo: Stephen Knapp

Hideaki Miyamura, **Ugly Duckling,** *2003*
yohen temoku glazed porcelain
photo: G. Berstein

WEISSPOLLACK

20th and 21st century artists working in two and three-dimensional art forms
Staff: Jeffrey Weiss, owner; David Pollack, owner/director; Sallie Hackett Brown, manager

139 East 57th Street
New York, NY 10022
voice 203.984.1398

2938 Fairfield Avenue
Bridgeport, CT 06605
voice 203.333.7733
fax 203.362.2628
weisspollack@att.net
jeffreyweissgallery.com

Representing:
Lanette Barber
Christopher Cantwell
Joshua Noah Dopp
Greg Fidler
Jamie Harris
Jim Leedy
Hideaki Miyamura
Thomas Throop
John A. Urbain

Jim Leedy, **Black Mamba***, 2003*
smoked stoneware, 40 x 21 x 21
photo: G. Berstein

153

Marilyn da Silva, **Pigment Basket,** *2004*
metal, copper, sterling silver, wood, gesso, colored pencil, paint, 13 x 10 x 4

Yaw Gallery

National and international goldsmiths and silversmiths
Staff: Nancy Yaw, director; Jim Yaw; Edith Robertson

550 North Old Woodward
Birmingham, MI 48009
voice 248.647.5470
fax 248.647.3715
yawgallery@msn.com

Representing:
Curtis H. Arima
Emanuela Aureli
Amy Bailey
Jennifer D. Banks
Elisa R. Bongfeldt
Deborah Boskin
Kathleen Bostick
Harlan Butt
Bridget Catchpole
Lily Cox-Richard
Jack da Silva
Marilyn da Silva
Marshal Dalva
Jennifer Dawes
Tony P. Esola
Amy Haskins
Angela Hennessy
Susan Hoge
David Huang
John Iversen
Olle Johanson
Ned Lane
Seung-Hea Lee
Christina A. Lemon
Deborah Lozier
Thomas Madden
Paula Judith Newman
Mary Ann Spavins
 Owen
Miel Paredes
Rebecca Reimers-
 Crystol
Claire Sanford
Nancy Slagle
Pamela Morris
 Thompford
Lydia Van Nostrand
Carol Webb
Susan Elizabeth Wood
Yoshiko Yamamoto
Sayumi Yokouchi

Susan Hoge, **Untitled,** *2003*
faceted citrine beads with yellow sapphire beaded beads, 16 x .75 x .5
photo: R.H. Hensleigh

SOFA 2004

Res

Resources

ources

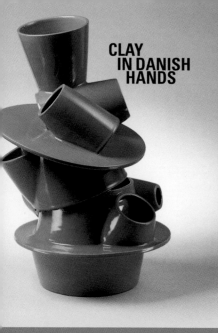

CLAY IN DANISH HANDS

BY DEBORAH KRASNER • PHOTOGRAPHS BY OLE AKHØJ

Living in Denmark for two years in the mid-80s was my opportunity to experience design heaven — it actually took work to find anything ugly or poorly made. Impeccable craftsmanship and quiet confidence in stark form are hallmarks of Danish object making, as they have been for most of the 20th century. These strengths are beautifully on view in "From the Kilns of Denmark," featuring 30 ceramists. The exhibition, curated by Wendy Tarlow Kaplan and Hope Barkan in association with the Danish Museum of Decorative Art, Copenhagen, and the Fitchburg Art Museum, Massachusetts, is touring in the United States before heading back to Europe in 2004.

Those who can't get to the exhibit will still be able to get a good sense of the work from the catalog and the video accompanying it. Although the book format somewhat limits our understanding of the scale of the pieces, their strong forms shine through. The video is a useful adjunct, as it introduces us to the potters and their process, information that was lacking in the exhibition labels.

It's a curious fact of Danish life that Danes, citizens of a tiny country with a total population of around 5.3 million, still feel as if they are at the center of the world. They find it quite unsurprising that they've held a leadership position in the design world for more than 50 years — they know they're that good. For the rest of us, particularly in this country, Danish pots teach us something we've lost touch with: the power of simple form and the seductive beauty of glaze. Training its potters in essentially two major craft schools — the Danish School of Arts and Crafts, Copenhagen, and the School of Arts and Crafts, Kolding — Denmark has created and extended a tradition of thinking analytically and rigorously about shape, and of letting glaze amplify the power of form.

The majority of pots in this exhibition, whether wheel-thrown, hand-built or cast, are based on the cylinder. This shape, the first that potters learn to throw, is akin to learning the alphabet by the letter "A" and then pursuing endless, deep explorations of all that "A" can do. Here, cylinders are quiet moving ringers to the form — as in works by Inger Rokkjær, Bodil Manz, Gertrud Vasegaard — or made rich with texture — as in those by Morten Løbner Espersen and Jane Reumert.

AMERICAN CRAFT

JUNE/JULY 02 $5

CRAFT

AUG/SEPT 02 $5

QUILT NATIONAL '03

In the 24 years since its inception, the juried biennial exhibition Quilt National has become a distinguished showcase for the art quilt. The 13th edition of this event, "Quilt National '03," opened at the Dairy Barn Southeastern Ohio Cultural Arts Center, Athens, May 24 through September 1, presenting 86 quilts by artists from 27 states and 11 foreign countries. The jurors, quilt artists Liz Axford and Wendy Huhn and Robert Shaw, author of The Art Quilt and other publications, drew their selection from 1,462 entries. Their statement in the catalog details the extensive jurying process and the general criteria that applied — good composition and color, a sense of content or theme, a coherent body of work, appropriate size, scale and workmanship. The works pictured here are among the 10 chosen by the jurors to receive awards.

Portions of the exhibition will travel to other venues through 2005. The itinerary and other information can be accessed at www.dairybarn.org. Quilt National 2003: The Best of Contemporary Quilts (Lark Books), 112 pages, introduction by Project Director Hilary Morrow Fletcher, illustrated, is $24.95 from the Dairy Barn, 740-592-4981 or rachel@dairybarn.org.

Clockwise from top: CORNELIA GOLLUB/EX, New York — discharge silk, cotton, hand painted, raw resist, collage, machine- and hand-quilted. 35 by 86 inches, Award of Excellence, photo Brian Blauser. BEAN GILSDORF, Oregon — dupioni silk, hand-dyed and commercial cotton, dyed, screen printed, painted, inkjet printed, machine-pieced, appliquéd, quilted, knit, 56 by 41 inches, Cathy Rasmussen Emerging Artist Memorial Award, sponsored by Studio Art Quilt Associates, photo Brian Blauser. MICHAEL JAMES, Nebraska — A Strange Riddle, cotton printed with digitally developed images into Photoshop, CAD software and a Mimaki textile plotter, machine-pieced and -quilted, 57 by 76 inches, Award for Most Innovative Use of the Medium, sponsored by Friends of Fiber Art International. CLARE PLUG, New Zealand — Nocturne in E, discharge-dyed cotton, machine-quilted, reverse appliquéd, 38 by 74 inches, Lynn Goodwin Borgman Memorial Award for Surface Design, photo Brian Blauser.

THE ART OF CRAFT

AMERICAN CRAFT is published bimonthly by the American Craft Council, the national organization providing leadership in the craft field since 1943. Annual membership in the Council, including a subscription to the magazine, $40, by contacting www.craftcouncil.org or 1-888-313-5527.

AMERICAN **CRAFT**
JUNE/JULY 03 $5

... have many. So in the Bullseye ... Their home is a mixture of what ... " in glass and the art the cou- ... ng with Bullseye's technicians ... cket to be collectors," McGre-

ous promenade continues, but in the form of more conventional glass art-works. Some are delicate, some muscular, but like the driveway and porch, every piece of glass in this collection was in a sense formed by Schwoer-er and McGregor, not as artists but as manufacturers of the actual mater-ial, at their firm, the Bullseye Glass Company, in Portland, Oregon (which Schwoerer, its current CEO, founded in 1974 with Ray Ahlgren and Boyce Lundstrom).

Bullseye produces some of the most vibrant colored glass in the world and has also been one of the most influential supporters of contemporary glass art through the technologies it has developed to make different glasses compatible (expansion and shrinkage variations being the chief problem in mixing glasses) and for its artist-in-residence programs and resource center/gallery, the Bullseye Connection. The company has grown from a start-up by what Schwoerer quips were "three hippies in a back-yard" of a rundown Victorian house to a factory covering nearly two city blocks where that house once stood. With similarly energetic improvisa-tion, they grew their home from an unremarkable 1,500-square-foot ranch-style bungalow bought in 1979 to what is now a 3,900-square-foot villa that Schwoerer calls "a great place to entertain," but which, McGregor unabashedly admits, is also very much "an extension of the business."

"We wanted to make a lab for the uses of the material to see how it can exist in the home beyond the usual method of putting things on shelves," Schwoerer says. "Glass collectors want to see the homes of other glass col-

Given the many artists Bullseye has hosted, the collection is extraordi-narily focused on those the couple believe have achieved technical or con-ceptual advances in the medium. On a wall over a counter, for instance, are a series of shelves lined with the ethereal goblets Dante Marioni blows each holiday season at Bullseye. The collection is a record of a collabora-tion now in its eighth year between Marioni and the Bullseye technician Sam Andreakos—one McGregor describes as "America's best young glassblower working with America's best glass color chemist."

Marioni requests a type of glass. Andreakos brews a batch. Marioni then uses it to blow goblets—or Cups, as he prefers to title them—so delicate they seem spun out of soap bubbles. Year one was clear crystal. Year two, Venetian topaz. Year three, a rare earth mineral called urbinium that results in a color best described as dichroic champagne. And so on, from cobalts to an opaque white to a straw-colored Italian glass known as "pagliesco."

Marioni's oo-ah example of blown-glass mastery is the exception in this collection, however. For the most part, Schwoerer and McGregor have turned their home, like their business, into an extended argument for the artistic equality of cast and fused glass, whose creators represent Bulls-eye's main clientele. In fact, in one prominent case, blown glass actually plays the foil in this collection.

Enter Schwoerer and McGregor's front door and the first piece to be noticed is their Dale Chihuly—a cluster of his *Reeds*—but positioned right next to what is easily their most valued piece, Klaus Moje's *Aperto 96*.

Originally two levels, the house now terraces down the hillside on four levels with a series of decks that fully exploit a 230-degree, four-volcano view.

Material Matters
At Home with
Dan Schwoerer and Lani McGregor

ABOVE: Jon Kaneko's 300-pound, six-feet-long arches of slumped glass create a focal point in the garden. LEFT: Sweden's Bertil Vallien comes every few years to the Bullseye factory to create a body of work in the sand-cast method of which he is a master. *Anoil* is a rare, up-turned wall-mounted piece made in 2000. *Annie* is prized on a mahogany and steel bench by the late Seattle artist/designer David Gulassa.

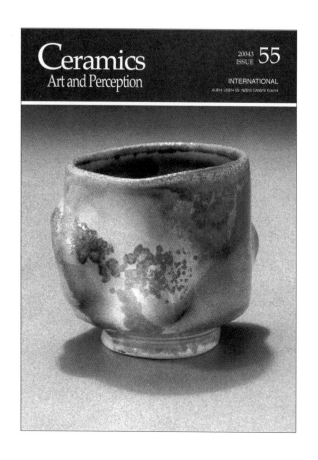
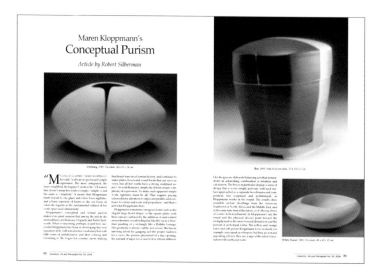

Technically speaking.

CERAMICS TECHNICAL

Ceramics TECHNICAL is a biannual magazine devoted to research in the ceramic arts. Articles cover innovative and traditional uses of materials and processes including clay and glazes, kilns and firing, forms, techniques and decorative methods. Photographs, diagrams, glaze receipes, workshops, book reviews and more.

Published May and November.
Cost: $35 (postage included). Credit cards welcome.

Ceramics
MONTHLY

The core of every good collection

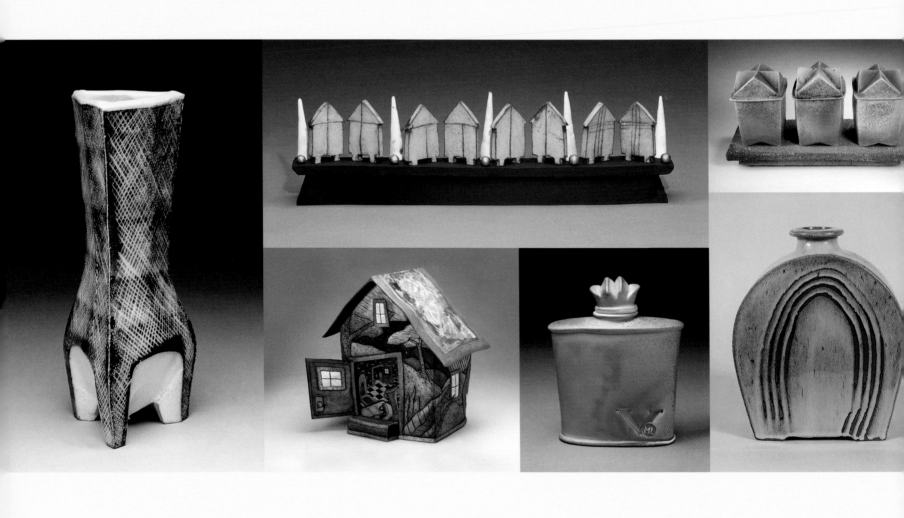

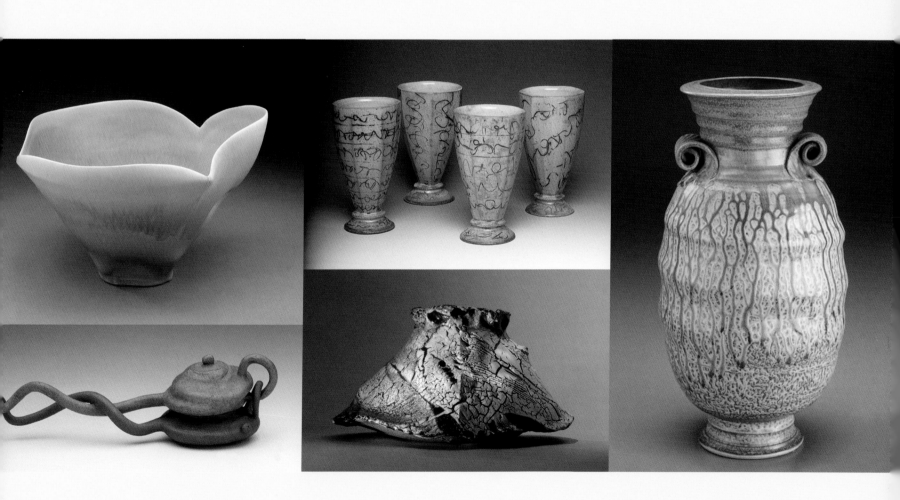

is inspiration.

UK: £5.50 • US: $11.95

CRAFTS

**TOY STORY:
DAVID SWIFT'S
CURIOUS CREATURES**

**MATERIAL GIRL:
REASSESSING EVA HESSE**

**MAKING HISTORY:
RE-EXAMINING THE STUDIO
POTTERY MOVEMENT**

UK: £5.50 • US: $11.95

crafts

**FERTILE
IMAGINATIONS:
Art for gardens**

FREE GARDEN SUPPLEMENT
Guide to best summer shows

crafts

The Magazine of Decorative and Applied Arts

DECORATIVE AND APPLIED ARTS • No.184 SEPTEMBER/OCTOBER 2003 UK: £5.50 • US: $11.95

crafts

RICH FITTINGS
Designer works for
Wycombe Square

STAGE STRUCK
The theatrical
ceramics of
Daniel Allen

CORNISH CONNECTIONS
Barbara Hepworth
and the crafts

INSPIRATION

INNOVATION

INFORMATION

THE MAGAZINE OF TEXTILES

SUMMER 2003

FIBERARTS

VOL. 30, NO. 1

$6.00 (Can. $8.00)

The Tapestries of Jon Eric Riis
Miniature Textiles Make It Big
3 Generations: Mentors & Students
Fiber Meets Glass

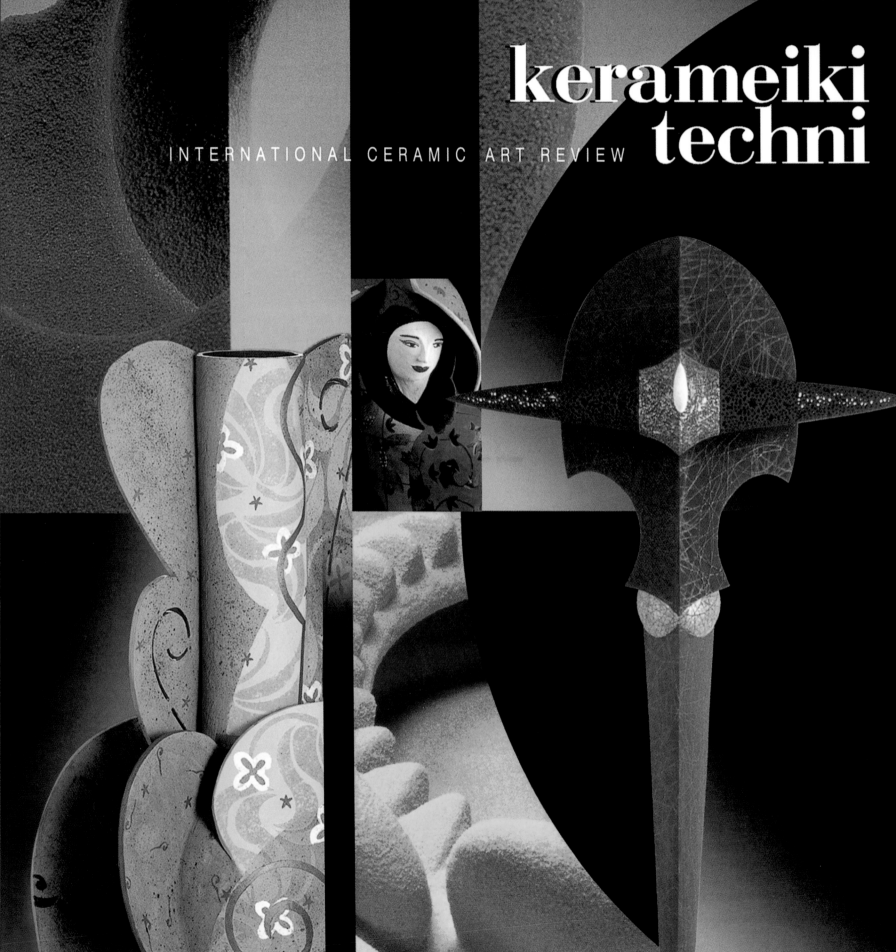

kerameiki techni

INTERNATIONAL CERAMIC ART REVIEW

Kerameiki Techni: *International Ceramic Art Review (1987)*

Published in Greece three times a year (April, August, December),in the English language, and distributed all over the world. In our subscribers' list are included Universities, Colleges, Ceramic Art Centers, Museums, Libraries, Galleries, Collectors, Writers, Art Critics, Architects, Interior Designers, Artists and Craftsmen– subscribers in 79 countries.

Presentations on both worldly acclaimed and lesser known artists
Scoops on up-and-coming new talents
Accounts on international exhibitions, competitions, symposiums and other events
Articles on traditional pottery
Recommendations and reviews on books, videos, catalogues and much more
All accompanied by excellent full colour illustrations

PANORAMA POSTER
Every issue includes an inserted full colour poster (50 x 80 cm), featuring the works of over 70 artists from recent exhibitions held all over the world. It is both an attractive visual record of current trends in the field of Contemporary Ceramic Art and a useful reference document for students, artists, scholars, writers, galleries, museums, and collectors.

SUBSCRIPTION RATES
Individuals:
One year subscription (3 issues)	(Euro) € 39.00 or US $ 45.00 (for USA readers only)
Price per copy (current or back issues)	€ 13.00 or US $ 15.00 (for USA readers only)

Air mail (A' priority) postage included.

Institutions:
Universities, Colleges, Schools, Museums, public or private Libraries, Foundations,
Art Centers, and other Educational or Cultural Institutions

One year subscription (3 issues)	(Euro) € 60.00 or US $ 69.00 (for USA readers only)
Price per copy (current or back issues)	€ 20.00 or US $ 23.00 (for USA readers only)

WAYS OF PAYMENT
Through our web site www.kerameikitechni.gr (secure site)
Bank check made out to the order of Kostas Tarkassis
Personal check
Credit Cards: Visa, MasterCard
Submit card number, expiry date, and cardholder's name and signature.
Send us by post, fax (in CAPITAL LETTERS), or email: Full name, address, tel/fax and email
Please specify clearly with which issue you wish to start your subscription and/or which back issues you wish
to order

Kerameiki Techni P.O. Box 76009, Nea Smyrni 17110, Athens - Greece
Tel/fax: ++30 210 932 5551 www.kerameikitechni.gr, kerameiki@otenet.gr

Published 6 times a year

KeramikMagazin
CeramicsMagazine

Nr. 5/2003 · Oktober/November · € 6,- · sfr 11,- · G 8031 F · mit KERAMIKcreativ

ssion und Spieltrieb: Fausto Salvi und Silvia Zotta • Der
t öffentliche Körper: „Corporal Identity" • Kate Malone:
Knoblauch, Ananas und mehr

KeramikMagazin
CeramicsMagazine

25. Jahrgang · Nr. 6/2003 · Dezember/Januar · € 6,- · sfr 11,- · G 8031 F · mit KERAMIKcreativ

Less is more: Julian Stair
Wiederbelebt: Keramiksymposium Gmunden
Waldwesen: Luz Arias de Borgmann

KeramikMagaz
CeramicsMag

26. Jahrgang · Nr. 1/2004 · Februar/März · € 6,- · sfr 11,- · G 8031 F

Nimm's leicht – aber genau! Bruno Fischer
Keramikbiennale ohne Keramiker in Alb
Endlich: Räume für das Keramik-Museum Berlin

KeramikMagazin
CeramicsMagazine

Nr. 3/2003 · Juni/Juli · € 6,- · sfr 11,- · G 8031 F

KeramikMagazin
CeramicsMagazine

25. Jahrgang · Nr. 4/2003 · August/September · € 6,- · sfr 11,- · G 8031 F · mit KERAMIKcreativ

KeramikMagazin
CeramicsMagazine

22. Jahrgang · Nr. 5/2000 · Oktober/November · DM 11,- · sfr 10,- · ATS 77,- · G 8031 F · mit KERAMIKcreativ

Keram

24. Jahrgang · Nr. 1/2002 · Februar/März · € 6,- · sfr

METALSMITH

JEWELRY ▪ DESIGN ▪ METAL ARTS WINTER 2004

volume 24 number 1
www.snagmetalsmith.org

The Best of International Glass Art around the world

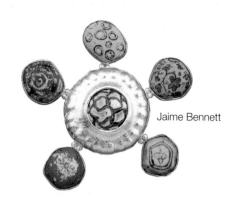
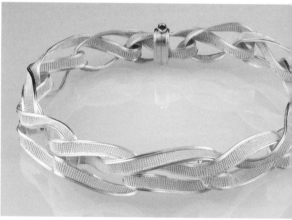

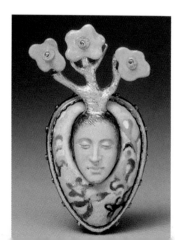

THE
DEVONSHIRE
INHERITANCE

Five Centuries of Collecting at Chatsworth

EXHIBITION
March 18– June 20, 2004

PUBLIC PROGRAM
British Craft Now - at SOFA

Lecture and guided tour led by
art historian Jane Adlin
Friday, June 4, 2004
10:30–12:00 noon

Tickets: $35 general;
$25 seniors and students
(includes admission to SOFA
NYC 2004 and a catalogue)

To register,
please call the Bard Graduate Center
Public Programs Department
at 212-501-3011
or e-mail programs@bgc.bard.edu

For exhibition information:
212-501-3023
gallery_assistant@bgc.bard.edu

The Devonshire Inheritance: Five Centuries of Collecting at Chatsworth is organized and circulated by Art Services International, Alexandria, Virginia.
Support for the national tour has been provided by the Annenberg Foundation, and by AXA Art Insurance, Ltd., London.
The catalogue has been funded in part by Sir Paul Getty, K.B.E., and the Samuel H. Kress Foundation.

Support for this exhibition at the Bard Graduate Center has been provided by Constance and Harvey Krueger, and Eugene V. Thaw.

The Bard Graduate Center for Studies in the Decorative Arts, Design, and Culture 18 West 86th Street, NYC 10024

Collectors of Wood Art

Salutes
David Ellsworth
2002 Recipient
Lifetime Achievement
Award

David Ellsworth received a masters degrees in sculpture from the University of Colorado in 1973. He started the woodworking program at the Anderson Ranch Arts Center in Snowmass, CO in 1974, and in 1975 opened his first private woodturning studio in Boulder, CO. During the mid-1970's David designed a series of bent turning tools and the methods required for making the thin-walled hollow forms for which he is known worldwide. His first article titled, "Hollow Turning" appeared in the May/June 1979 issue of *Fine Woodworking* magazine.

David is the founding member of the American Association of Woodturners, of which he was president from 1986-1991, and its first Honorary Lifetime Member. He has written over 50 articles on subjects related to woodturning and operates the Ellsworth School of Woodturning at his studio in Buck's County, PA. His works have been included in the permanent collections of 20 museums, including the Metropolitan Museum of Art in NYC, the Philadelphia Museum of Art, and the Mint Museum of Craft + Design in Charlotte, NC, as well as private national and international collections. He has received fellowship grants from the National Endowment of Arts, the Pennsylvania Council for the Arts, and the PEW Foundation and was recently honored as a Fellow of the American Craft Council.

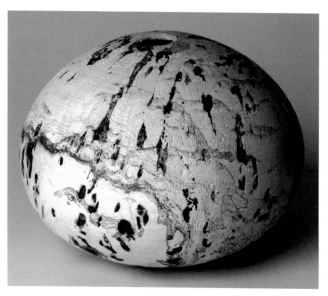

"Hickory Pot" 2004, Hickory Burl, 5"h x 6"d

CREATIVE GLASS CENTER OF AMERICA
AT WHEATON VILLAGE

2004 Fellowship Recipients:

Timothy Blum, New York
Stephen Paul Day, Louisiana
Einar de la Torre, Mexico/California
Jamex de la Torre, Mexico/California
Simone Fezer, Germany
Jens Gussek, Germany
Rick Mills, Hawaii
Sibylle Peretti, Louisiana
Sisar Sahana, India
Dave Walters, Washington
Ben Wright, Vermont
Mark Zirpel, Washington

**The Creative Glass Center of America
and the Art Alliance of Contemporary Glass announce:**

Glass Weekend '05

July 15, 16, and 17, 2005

GlassWeekend is an international symposium and exhibition of contemporary glass, sponsored by the Creative Glass Center of America (CGCA) and the Art Alliance for Contemporary Glass.

FOR MORE INFORMATION

Call 856-825-6800, or visit www.wheatonvillage.org
1501 Glasstown Road, Millville, NJ 08332

NEW JERSEY STATE COUNCIL ON THE ARTS
www.njartscouncil.org

NATIONAL ENDOWMENT FOR THE ARTS

Discover JERSEY ARTS

Wheaton Village strives to make our exhibitions, events and programs accessible to all visitors. Call for details. Funding has been made possible in part by the New Jersey State Council on the Arts/Department of State, a Partner Agency of the National Endowment for the Arts, and the Geraldine R. Dodge Foundation. This project is supported in part by an award from the National Endowment for the Arts, which believes that a great nation deserves great art.

UPCOMING EVENTS AT WHEATON VILLAGE:

GLASS THREADS:
Tiffany-Quezal-Imperial-Durand
April 3rd to January 2nd, 2005

NATIVE TO NEO:
Mexican Folk Arts from Oaxaca
July 9th to November 12th, 2004

FESTIVAL OF FINE CRAFT
October 2nd & 3rd, 2004

MEXICAN FIESTA
Music, Dance, and Craft
October 29th, 30th & 31st, 2004

DAVID LING ARCHITECT • CRAFTED INTERIORS FOR THE COLLECTOR • WWW.DAVIDLINGARCHITECT.COM

CELEBRATE AMERICAN CRAFT ART AND ARTISTS
JOIN THE JAMES RENWICK ALLIANCE.

LEARN
about contemporary crafts at our seminars,

SHARE
in the creative vision of craft artists at workshops,

REACH OUT
by supporting our programs for school children,

INCREASE
your skills as a connoisseur,

ENJOY
the comaraderie of fellow craft enthusiasts,

PARTICIPATE
in Craft Weekend including symposium and auction, and

TRAVEL
with fellow members on our craft study tours.

Steven Ford and David Forlano Triple Urchin Pin **P**Photograph by Robert R. Diamante

As a member you will help build our nation'spremiere collection of contemporary American craft art at the Renwick Gallery.

The James Renwick Alliance, founded in 1982, is the exclusive support group of the Renwick Gallery of the Smithsonian American Art Museum.

For more information: Call 301-907-3888. Or visit our website: www.jra.org

BENCHMark

May 1 — September 12, 2004
Wednesdays and Saturdays 2–5 pm

LongHouse Reserve • 133 Hands Creek Road • East Hampton, NY 11937
TEL. **631.329.3568** FAX **631.329.4299** www.longhouse.org

Cedar and Willow Settle, by Feir Mill Design, Omemee, Canada | collection LongHouse Reserve, gift of Anne Roberts

LONGHOUSE

Honoring American Masters:
Larsen, Stankard and Schepps

Jack Lenor Larsen: Creator and Collector
The dean of American textile design
May 28 – August 29, 2004

Paul Stankard: A Floating World
Forty years of an American master in glass
May 28 – August 29, 2004

Seaman Schepps: A Century of New York
Jewelry Design 1904-2004
September 8, 2004 – January 5, 2005

Celebrating the Finest in Craft,
Decorative Arts and Design

While you're at SOFA, please visit us on 53rd Street

Jack Lenor Larsen
Remoulade, from the Spice
Garden Collection,1956
Cotton, silk, Lurex; wool,
linen, jute, rayon; woven
Collection Cowtan & Tout
Photo: Richard Goodbody

Museum of Arts & Design
40 West 53rd Street
New York, NY 10019
212.956.3535
www.madmuseum.org
(formerly American Craft Museum)

Paul J. Stankard
Bouquet Botanical, 1989
Belkin Collection
Photo: John Bigelow Taylor

Wood Turning Center

Wood And Other Lathe-Turned Art

education
preservation
promotion

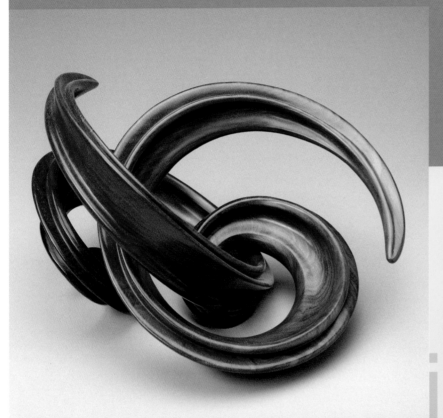

Turning Points includes reviews of exhibitions, conferences and symposia; articles on the art of lathe-turning, from authentic historical reproductions to the most avant-garde; conservation, collector and artist issues. Free one-year subscription with membership.

join us

Wood Turning Center
501 Vine Street, Philadelphia, PA 19106
tel: 215.923.8000
fax: 215.923.4403
turnon@woodturningcenter.org
www.woodturningcenter.org

Hours:
Monday–Friday 10am-5pm
Saturday 12pm-5pm

Members of the Wood Turning Center play a vital role by helping to fulfill its mission of education, preservation and promotion. Because you may share an interest in lathe turning or related arts, we invite you to support WTC with your membership.

Founded in 1986, the Wood Turning Center, a Philadelphia-based not-for-profit arts institution, gallery and resource center, is dedicated to the art and craft of lathe-turned objects. Through its programs, the Center encourages existing and future artists, and cultivates a public appreciation of the field.

Deepen both your knowledge and appreciation of the art of lathe-turning and gain insight into the artists who are expanding the art and craft of wood turning. Contact the Center by phone or visit our web site for details.

SOFA 2004

Ex

hibitors

Aaron Faber Gallery
666 Fifth Avenue
New York, NY 10103
212.586.8411
fax 212.582.0205
info@aaronfaber.com
aaronfaber.com

Ann Nathan Gallery
212 West Superior Street
Chicago, IL 60610
312.664.6622
fax 312.664.9392
nathangall@aol.com
annnathangallery.com

Artempresa Gallery
San Jeronimo 448
Cordoba 5000
Argentina
54.351.422.1290
fax 54.351.427.1776
artempresa@arnet.com.ar
artempresagallery.org

Barry Friedman Ltd.
32 East 67th Street
New York, NY 10021
212.794.8950
fax 212.794.8889
contact@barryfriedmanltd.com
barryfriedmanltd.com

Berengo Fine Arts
Fondamenta del Vetrai, 109/A
Murano, Venice, Italy
39.041.527.6364
fax 39.041.527.6588
adberen@berengo.com
berengo.com

Brendan Walter Gallery
960 Alameda Avenue
Monterey, CA 93940
831.373.6900
fax 831.373.0900
brendanwlt@aol.com

browngrotta arts
Wilton, CT
203.834.0623
800.666.0623
fax 203.762.5981
art@browngrotta.com
browngrotta.com

Caterina Tognon Arte Contemporanea
Via San Tomaso, 72
Bergamo 24121
Italy
39.035.243300
fax 39.035.243300
caterinatognon@tin.it
caterinatognon.com

Chappell Gallery
526 West 26th Street, #317
New York, NY 10001
212.414.2673
fax 212.414.2678
amchappell@aol.com
chappellgallery.com

14 Newbury Street
Boston, MA 02116
617.236.2255
fax 617.236.5522

Charon Kransen Arts
By Appointment Only
357 West 19th Street, Suite 2E
New York, NY 10011
212.627.5073
fax 212.633.9026
chakran@earthlink.net
charonkransenarts.com

Clay
226 Main Street
Venice, CA 90291
310.230.9202
fax 301.230.9203
clayinla@earthlink.net

Dai Ichi Arts, Ltd.
249 East 48th Street
New York, NY 10017
212.230.1680
fax 212.230.1618
daiichiarts@yahoo.com
daiichiarts.com

The David Collection
44 Black Spring Road
Pound Ridge, NY 10576
914.764.4674
fax 914.764.5274
jkdavid@optonline.net
thedavidcollection.com

del Mano Gallery
11981 San Vicente Boulevard
Los Angeles, CA 90049
310.476.8508
fax 310.471.0897
gallery@delmano.com
delmano.com

Donna Schneier Fine Arts
By Appointment Only
New York, NY
212.472.9175
fax 212.472.6939
dnnaschneier@mhcable.com

Ferrin Gallery
69 Church Street
Lenox, MA 01240
413.637.4414
fax 914.271.0047
info@ferringallery.com
ferringallery.com

Finer Things Gallery
1898 Nolensville Road
Nashville, TN 37210
615.244.3003
fax 615.254.1833
kkbrooks@bellsouth.net
finerthingsgallery.com

Franklin Parrasch Gallery
20 West 57th Street
New York, NY 10019
212.246.5360
fax 212.246.5391
info@franklinparrasch.com
franklinparrasch.com

Galerie Ateliers d'Art de France
22 Avenue Niel
Paris 75017
France
33.14.888.0658
fax 33.14.440.2368
galerie@ateliersdart.com
createdinfrance.com/artwork

Galerie b15–Renate Wunderle
Baaderstrasse 15
Munich D-80469
Germany
49.89.202.1010
fax 49.89.642.1445
b15-wunderle@t-online.de
b15-wunderle.com

Galerie Daniel Guidat
142 Rue d'Antibes
Cannes 06400
France
33.49.394.3333
fax 33.49.394.3334
gdg@danielguidat.com
danielguidat.com

Galerie Elena Lee
1460 Sherbrooke West
Suite A
Montreal, Quebec H3G 1K4
Canada
514.844.6009
fax 514.844.1335
info@galerieelenalee.com
galerieelenalee.com

Galerie Tactus
Gothersgade 54
Copenhagen 1123
Denmark
45.33.933105
fax 45.35.431549
tactus@galerietactus.com
galerietactus.com

Gallery Materia
4222 North Marshall Way
Scottsdale, AZ 85251
480.949.1262
fax 480.949.6050
gallery@gallerymateria.com
gallerymateria.com

Garth Clark Gallery
24 West 57th Street, #305
New York, NY 10019
212.246.2205
fax 212.489.5168
mark@garthclark.com
garthclark.com

Helen Drutt: Philadelphia
By Appointment Only
2220-22 Rittenhouse Square
Philadelphia, PA 19103-5505
215.735.1625
fax 215.732.1382

Heller Gallery
420 West 14th Street
New York, NY 10014
212.414.4014
fax 212.414.2636
info@hellergallery.com
hellergallery.com

Holsten Galleries
3 Elm Street
Stockbridge, MA 01262
413.298.3044
fax 413.298.3275
artglass@holstengalleries.com
holstengalleries.com

Jewelers' Werk Galerie
2000 Pennsylvania Avenue NW
Washington, DC 20006
202.293.0249
fax 202.659.4149
ellenreiben@earthlink.net

Joan B. Mirviss, Ltd.
PO Box 231095
Ansonia Station
New York, NY 10023
212.799.4021
fax 212.721.5148
joan@mirviss.com
mirviss.com

John Natsoulas Gallery
521 First Street
Davis, CA 95616
530.756.3938
fax 530.756.3961
art@natsoulas.com
natsoulas.com

Lacoste Gallery
25 Main Street
Concord, MA 01742
978.369.0278
fax 978.369.3375
lacoste@gis.net
lacostegallery.com

Lea Sneider
211 Central Park West
New York, NY 10024
212.724.6171
fax 212.769.3156
learsneider@aol.com

Leo Kaplan Modern
41 East 57th Street
7th floor
New York, NY 10022
212.872.1616
fax 212.872.1617
lkm@lkmodern.com

Loveed Fine Arts
575 Madison Avenue
Suite 1006
New York, NY 10022-2511
212.605.0591
fax 212.605.0592
loveedfinearts@earthlink.net
loveedfinearts.com

Marx-Saunders Gallery, Ltd.
230 West Superior Street
Chicago, IL 60610
312.573.1400
fax 312.573.0575
marxsaunders@earthlink.net
marxsaunders.com

Maurine Littleton Gallery
1667 Wisconsin Avenue NW
Washington, DC 20007
202.333.9307
fax 202.342.2004
littletongallery@aol.com

Mobilia Gallery
358 Huron Avenue
Cambridge, MA 02138
617.876.2109
fax 617.876.2110
mobiliaart@aol.com
mobilia-gallery.com

Moderne Gallery
111 North 3rd Street
Philadelphia, PA 19106
215.923.8536
fax 215.923.8435
raibel@aol.com
modernegallery.com

Modus Gallery
23 Place des Vosges
Paris 75003
France
33.14.278.1010
fax 33.14.278.1400
modus@noos.fr
galerie-modus.com

Mostly Glass Gallery
3 East Palisade Avenue
Englewood, NJ 07631
201.816.1222
fax 201.816.9582
info@mostlyglass.com
mostlyglass.com

Nancy Margolis Gallery
523 West 25th Street
New York, NY 10001
212.242.3013
fax 212.242.4087
nancymargolisgallery.com

Option Art
4216 de Maisonneuve Blvd.
West
Suite 302
Montreal, Quebec H3Z 1K4
Canada
514.932.3987
fax 514.932.6182
info@option-art.ca
option-art.ca

Orley Shabahang
240 South County Road
Palm Beach, FL 33480
561.655.3371
geoffreyorley@aol.com
shabahangcarpets.com

R. Duane Reed
7513 Forsyth Boulevard
St. Louis, MO 63105
314.862.2333
fax 314.862.8557
reedart@primary.net
rduanereedgallery.com

711 East Las Olas Boulevard
Fort Lauderdale, FL 33301
954.525.5210
fax 954.525.5206
flareedart@primary.net

Sienna Gallery
80 Main Street
Lenox, MA 01240
413.637.8386
fax 413.637.8387
info@siennagallery.com
siennagallery.com

Snyderman-Works Galleries
303 Cherry Street
Philadelphia, PA 19106
215.238.9576
fax 215.238.9351
bruce@snyderman-works.com
snyderman-works.com

Tai Gallery/Textile Arts
616 1/2 Canyon Road
Santa Fe, NM 87501
505.983. 9780
fax 505.989.7770
gallery@textilearts.com
textilearts.com

Thomas R. Riley Galleries
642 North High Street
Columbus, OH 43215
614.228.6554
fax 614.228.6550
columbusinfo@rileygalleries.co
rileygalleries.com

2026 Murray Hill Road
Cleveland, OH 44106
216.421.1445
fax 216.421.1435
clevelandinfo@rileygalleries.com

**UrbanGlass New York
Contemporary Glass Center**
647 Fulton Street
Brooklyn, NY 11217-1112
718.625.3685
fax 718.625.3889
info@urbanglass.org
urbanglass.org

Yaw Gallery
550 North Old Woodward
Birmingham, MI 48009
248.647.5470
fax 248.647.3715
yawgallery@msn.com

Walker Fine Art
478 West Broadway
New York, NY 10012
347.563.2100
fax 646.840.9999
rockartusa@msn.com

WEISSPOLLACK
2938 Fairfield Avenue
Bridgeport, CT 06605
203.333.7733
fax 203.362.2628
weisspollack@att.net
jeffreyweissgallery.com

139 East 57th Street
New York, NY 10022
203.984.1398

SOFA 2004

Artists

Abe, Motoshi
Tai Gallery/Textile Arts

Abraham, Françoise
Modus Gallery

Adams, Dan
Mobilia Gallery

Adams, Hank
Heller Gallery

Adams, Renie Breskin
Mobilia Gallery

Adler, Deborah
UrbanGlass New York
 Contemporary Glass Center

Agostinho, Fernando
Galerie Daniel Guidat

Ahlgren, Jeanette
Mobilia Gallery

Akers, Adela
browngrotta arts

Alepedis, Efharis
Charon Kransen Arts

Amromin, Pavel
Ann Nathan Gallery

Anderson, Dona
browngrotta arts

Anderson, Jeannine
browngrotta arts

Angelino, Gianfranco
del Mano Gallery

Aoki, Mikiko
The David Collection

Arata, Tomomi
The David Collection
Mobilia Gallery

Arentzen, Glenda
Aaron Faber Gallery

Arima, Curtis H.
Yaw Gallery

Arneson, Robert
Franklin Parrasch Gallery
John Natsoulas Gallery

Arp, Marijke
browngrotta arts

Arroyave-Portela, Nicholas
Helen Drutt: Philadelphia

Asay, Roger
Gallery Materia

Aureli, Emanuela
Yaw Gallery

Aylief, Felicity
Clay

Baacke, Till
Charon Kransen Arts

Babetto, Giampaolo
Sienna Gallery

Babula, Maryann
Chappell Gallery

Bacsh, Sara
The David Collection

Bahlmann, Alexandra
Jewelers' Werk Galerie

Bailey, Amy
Yaw Gallery

Baines, Robert
Helen Drutt: Philadelphia

Bakker, Gijs
Helen Drutt: Philadelphia

Bakker, Ralph
Charon Kransen Arts

Baldwin, Gordon
Galerie b15–Renate Wunderle

Balsgaard, Jane
browngrotta arts

Banks, Jennifer D.
Yaw Gallery

Barber, Lanette
WEISSPOLLACK

Barker, Jo
browngrotta arts

Barnaby, Margaret
Aaron Faber Gallery

Barnes, Dorothy Gill
browngrotta arts

Barry, Donna
Mobilia Gallery

Bartels, Rike
Charon Kransen Arts

Bartlett, Caroline
browngrotta arts

Bauer, Ela
Charon Kransen Arts

Bauhuis, Peter
Jewelers' Werk Galerie

Becker, Michael
Charon Kransen Arts

Bégou, Alain
Galerie Daniel Guidat

Bégou, Francis
Galerie Daniel Guidat

Bégou, Marisa
Galerie Daniel Guidat

Behar, Linda
Mobilia Gallery

Behennah, Dail
browngrotta arts

Behrens, Hanne
Mobilia Gallery

Beiner, Susan
Lacoste Gallery

Benglis, Lynda
Franklin Parrasch Gallery

Bennett, David
Thomas R. Riley Galleries

Bennett, Garry Knox
Leo Kaplan Modern

Bennett, Jamie
Sienna Gallery

Bennicke, Karen
Nancy Margolis Gallery

Bernardi, Luis
Artempresa Gallery

Bernstein, Alex Gabriel
Chappell Gallery

Bero, Mary
Ann Nathan Gallery

Bess, Nancy Moore
browngrotta arts

Bettison, Giles
Barry Friedman Ltd.

Betz, Doris
Jewelers' Werk Galerie

Bielander, David
Jewelers' Werk Galerie

Bijlenga, Marian
Gallery Materia

Birch, Karin
Snyderman-Works Galleries

Birkkjaer, Birgit
browngrotta arts

Bischoff, Manfred
Helen Drutt: Philadelphia

Bjerring, Claus
Galerie Tactus

Blackman, Jane
Clay

Blavarp, Liv
Charon Kransen Arts

Bloomfield, Greg
Leo Kaplan Modern

**Bobrowicz, Yvonne
Pacanowsky**
Snyderman-Works Galleries

Bodemer, Iris
Jewelers' Werk Galerie

Bongfeldt, Elisa R.
Yaw Gallery

Bonovitz, Jill
Helen Drutt: Philadelphia

Book, Flora
Mobilia Gallery

Borghesi, Marco
Aaron Faber Gallery

Boskin, Deborah
Yaw Gallery

Bostick, Kathleen
Yaw Gallery

Boucard, Yves
Leo Kaplan Modern

Boyadjiev, Latchezar
Thomas R. Riley Galleries

Boyd, Michael
Mobilia Gallery

Braeuer, Antje
Charon Kransen Arts

Brennan, Sara
browngrotta arts

Brinkmann, Beate
The David Collection

Britton, Helen
Jewelers' Werk Galerie

Bronstein, Leon
Modus Gallery

Brooks, Lola
Sienna Gallery

Brown, Sandy
Clay

Brychtová, Jaroslova
Barry Friedman Ltd.
Brendan Walter Gallery
Donna Schneier Fine Arts

Buckman, Jan
browngrotta arts

Budge, Susan
Loveed Fine Arts

Buge-Buchert, Ute
Aaron Faber Gallery

Burchard, Christian
del Mano Gallery

Butt, Harlan
Yaw Gallery

Byrd, John
Garth Clark Gallery

Calderwood, Jessica
Aaron Faber Gallery

Caleo, Lyndsay
Chappell Gallery

Campbell, Pat
browngrotta arts

Cantin, Annie
Galerie Elena Lee

Cantwell, Christopher
WEISSPOLLACK

Carlson, William
Brendan Walter Gallery
Leo Kaplan Modern
Marx-Saunders Gallery, Ltd.

Carman, Nancy
Helen Drutt: Philadelphia

Caro, Sir Anthony
Garth Clark Gallery

Caruso, Nino
Loveed Fine Arts

Castle, Wendell
Brendan Walter Gallery
Donna Schneier Fine Arts
Leo Kaplan Modern
Moderne Gallery

Catchpole, Bridget
Yaw Gallery

Cavalan, Pierre
Helen Drutt: Philadelphia

Cederquist, John
Franklin Parrasch Gallery

Cepka, Anton
Charon Kransen Arts

Champy, Claude
Galerie b15–Renate Wunderle

Chandler, Gordon
Ann Nathan Gallery

Chang, Peter
Helen Drutt: Philadelphia

Chardiet, José
Leo Kaplan Modern
Marx-Saunders Gallery, Ltd.

Charles, Don
Thomas R. Riley Galleries

Chaseling, Scott
Leo Kaplan Modern

Chatt, David K.
Mobilia Gallery

Chavent
Aaron Faber Gallery

Chen, Yu Chun
Charon Kransen Arts

Chesney, Nicole
Heller Gallery

Chihuly, Dale
Brendan Walter Gallery
Donna Schneier Fine Arts

Chmelar, Pascal
Lacoste Gallery

Choo, Chunghi
browngrotta arts

Christie, Barbara
The David Collection

Church, Sharon
Helen Drutt: Philadelphia

Class, Petra
Charon Kransen Arts

Claudel, Camille
John Natsoulas Gallery

Clausager, Kirsten
Mobilia Gallery

Clayton, Deanna
Thomas R. Riley Galleries

Clayton, Keith
Thomas R. Riley Galleries

Coates, Kevin
Mobilia Gallery

Cole, Jim
Mobilia Gallery

Cook, Lia
Nancy Margolis Gallery

Cooper, Robert
Clay

Copping, Brad
Galerie Elena Lee

Cordova, Cristina
Ann Nathan Gallery

Corvaja, Giovanni
Charon Kransen Arts

Costantini, Vittorio
Mostly Glass Gallery

Cottrell, Simon
Charon Kransen Arts

Cousens, Cynthia
Jewelers' Werk Galerie

Cox-Richard, Lily
Yaw Gallery

Crain, Joyce
Snyderman-Works Galleries

Crawford, Sarah
Mobilia Gallery

Cribbs, KéKé
Leo Kaplan Modern

Cross, Susan
Mobilia Gallery

Cucchi, Claudia
Charon Kransen Arts

Curneen, Claire
Clay

Currier, Anne
Helen Drutt: Philadelphia

da Silva, Jack
Mobilia Gallery
Yaw Gallery

da Silva, Marilyn
Mobilia Gallery
Yaw Gallery

Dailey, Dan
Brendan Walter Gallery
Leo Kaplan Modern

Daley, William
Helen Drutt: Philadelphia

Dalva, Marshal
Yaw Gallery

Damas, Martine
Galerie Ateliers
 d'Art de France

Daraspe, Roland
Galerie Ateliers
 d'Art de France

Dardek, Dominique
Modus Gallery

Darty, Linda
Aaron Faber Gallery

Davey, Matt
Ann Nathan Gallery

Dawes, Jennifer
Yaw Gallery

Day, Paul
Garth Clark Gallery

De Forest, Roy
John Natsoulas Gallery

de Santillana, Laura
Barry Friedman Ltd.

DeBoth, Carol
The David Collection

DeBuck, Siegfried
Mobilia Gallery

Debus, Monika
Galerie b15–Renate Wunderle

Dei Rossi, Antonio
Mostly Glass Gallery

Dei Rossi, Mario
Mostly Glass Gallery

Déjonghe, Bernard
Galerie b15–Renate Wunderle

Dempf, Martina
The David Collection

DeStaebler, Stephen
Franklin Parrasch Gallery

DeVore, Richard
Donna Schneier Fine Arts

Di Fiore, Miriam
Mostly Glass Gallery

Diduk, Barbara
Nancy Margolis Gallery

Dillingham, Rick
Donna Schneier Fine Arts

Dittlmann, Bettina
Jewelers' Werk Galerie

Dixon, Steven
Clay

Dobler, Georg
Helen Drutt: Philadelphia

Dolack, Linda
Mobilia Gallery

Dombrowski, Joachim
The David Collection

Domenech, Xavier
Jewelers' Werk Galerie

Donat, Ingrid
Barry Friedman Ltd.

Donzelli, Maurizio
Caterina Tognon Arte
 Contemporanea

Doolan, Devta
Aaron Faber Gallery

Dopp, Joshua Noah
WEISSPOLLACK

Dorph-Jensen, Sidsel
Galerie Tactus

Douglas, Mason
Jewelers' Werk Galerie

Druin, Erica
Aaron Faber Gallery

Druin, Marilyn
Aaron Faber Gallery

Drury, Chris
browngrotta arts

Dubois, Valerie
The David Collection

Duong, Sam Tho
Charon Kransen Arts

Earl, Jack
Nancy Margolis Gallery

Eberle, Edward
Garth Clark Gallery

Ebner, David
Moderne Gallery

Ehmck, Nina
The David Collection

Eid, Cynthia
Mobilia Gallery

Eisch, Erwin
Barry Friedman Ltd.

Ellison-Dorion, Helen
Mobilia Gallery

Ellsworth, David
del Mano Gallery

Elyashiv, Noam
Sienna Gallery

Emmerique, Isabelle
Galerie Daniel Guidat

Emms, Dawn
Mobilia Gallery

English, Joseph
Aaron Faber Gallery

Epp, Sophia
Jewelers' Werk Galerie

Erickson, Michelle
Lacoste Gallery

Esherick, Wharton
Moderne Gallery

Esola, Tony P.
Yaw Gallery

F

Falkesgaard, Lina
Galerie Tactus

Fanourakis, Lina
Aaron Faber Gallery

Farey, Lizzie
browngrotta arts

Feibleman, Dorothy
Mobilia Gallery

Fennell, J. Paul
del Mano Gallery

Ferguson, Ken
Moderne Gallery

Ferrari, Gerard
Ann Nathan Gallery

Fidler, Greg
WEISSPOLLACK

Fisch, Arline
Mobilia Gallery

Fleming, Ron
del Mano Gallery

Flockinger, CBE, Gerda
Mobilia Gallery

Folino, Tom
Loveed Fine Arts

Fouilhoux, Jean-François
Galerie b15–Renate Wunderle

Foulem, Léopold L.
Option Art

Frank, Peter
Charon Kransen Arts

Franke, Liz
Gallery Materia

Freda, David
Mobilia Gallery

Freeman, Warwick
Jewelers' Werk Galerie

Frève, Carole
Galerie Elena Lee

Friedlich, Donald
Sienna Gallery

Fritsch, CBE, Elizabeth
Mobilia Gallery

Fritsch, Karl
Jewelers' Werk Galerie

Fujii, Keitaro
Gallery Materia

Fujimoto, Tetsuo
Lea Sneider

Fujinuma, Noboru
Tai Gallery/Textile Arts

Fujita, Emi
Mobilia Gallery

Fujita, Kyohei
Thomas R. Riley Galleries

Fukami, Sueharu
Lea Sneider

Fukuchi, Kyoko
The David Collection
Helen Drutt: Philadelphia

Galloway-Whitehead, Gill
The David Collection

Garrett, John
Mobilia Gallery

Gentille, Thomas
Helen Drutt: Philadelphia
Jewelers' Werk Galerie

Giguere, Jean-Marie
Option Art

Giles, Mary
browngrotta arts

Glancy, Michael
Barry Friedman Ltd.

Glendinning, John
Galerie Elena Lee

Gnaedinger, Ursula
Charon Kransen Arts
The David Collection

Goldenberg, Leonor
Artempresa Gallery

Good, Michael
Aaron Faber Gallery
The David Collection

Goodman, Jeff
Galerie Elena Lee

Grecco, Krista
Ann Nathan Gallery

Green, Linda
browngrotta arts

Gross, Michael
Ann Nathan Gallery

Grossen, Françoise
browngrotta arts

Grotell, Maija
Moderne Gallery

Grove, Scott
Finer Things Gallery

Guillermo, Rosario
Artempresa Gallery

Gurhan
Charon Kransen Arts

Gut, Andi
Charon Kransen Arts

Hafermalz-Wheeler, Christine
Aaron Faber Gallery

Hafner, Dorothy
R. Duane Reed

Halabi, Sol
Artempresa Gallery

Hamada, Shoji
Dai Ichi Arts, Ltd.
Joan B. Mirviss, Ltd.

Hanagarth, Sophie
Charon Kransen Arts

Hardenberg, Torben
Galerie Tactus

Harding, Tim
Gallery Materia

Harris, Jamie
UrbanGlass New York
 Contemporary Glass Center
WEISSPOLLACK

Harvey, Mielle
Jewelers' Werk Galerie
Mobilia Gallery

Haskins, Amy
Yaw Gallery

Hatakeyama, Seido
Tai Gallery/Textile Arts

Hatekayama, Norie
browngrotta arts

Hayashi, Yasuo
Dai Ichi Arts, Ltd.

Hayashibe, Masako
The David Collection

Hector, Valerie
Charon Kransen Arts

Heffernon, Gerald
John Natsoulas Gallery

Heindl, Anna
Charon Kransen Arts

Heinemann, Steven
Nancy Margolis Gallery

Hennessy, Angela
Yaw Gallery

Henricksen, Ane
browngrotta arts

Henton, Maggie
browngrotta arts

Hermsen, Herman
Charon Kransen Arts

Hernmarck, Helena
browngrotta arts

Hibbert, Louise
del Mano Gallery

Hicks, Sheila
browngrotta arts

Hieda, Makoto
Mobilia Gallery

Higashi, April
Aaron Faber Gallery

Higashida, Shigemasa
Dai Ichi Arts, Ltd.

Higby, Wayne
Helen Drutt: Philadelphia

Hild, Eva
Nancy Margolis Gallery

Hildebrandt, Marion
browngrotta arts

Hill, Chris
Ann Nathan Gallery

Hiramatsu, Yasuki
Charon Kransen Arts

Hirte, Lydia
The David Collection

Hobin, Agneta
browngrotta arts

Hoge, Susan
Yaw Gallery

Hollibaugh, Nick
Mobilia Gallery

Holmes, Kathleen
Chappell Gallery

Honda, Syoryu
Tai Gallery/Textile Arts

Honma, Hideaki
Tai Gallery/Textile Arts

Honma, Kazue
browngrotta arts

Horn, Robyn
del Mano Gallery

Horrell, Deborah
Gallery Materia

Howelett, Ray
Modus Gallery

Hu, Mary Lee
Mobilia Gallery

Huang, David
Yaw Gallery

Hübel, Angela
Jewelers' Werk Galerie

Huchthausen, David
Leo Kaplan Modern

Huff, Melissa
Aaron Faber Gallery

Hughto, Margie
Loveed Fine Arts

Hunt, Kate
browngrotta arts

Hunter, Lissa
Nancy Margolis Gallery

Hunter, Marianne
Aaron Faber Gallery

Hunter, William
Barry Friedman Ltd.

Hurlin, Jean-Louis
Galerie Ateliers
 d'Art de France

Hutter, Sidney
Marx-Saunders Gallery, Ltd.

Huycke, David
Galerie Tactus

Hyman, Sylvia
Finer Things Gallery

Ida, Shoichi
Lea Sneider

Iezumi, Toshio
Chappell Gallery

Ishida, Meiri
Charon Kransen Arts

Ishikawa, Mari
Jewelers' Werk Galerie

Ishiyama, Reiko
Charon Kransen Arts

Isupov, Ilya
Ferrin Gallery

Isupov, Sergei
Ferrin Gallery

Isupov, Vladimir
Ferrin Gallery

Isupova, Nelli
Ferrin Gallery

Iversen, John
Charon Kransen Arts
Jewelers' Werk Galerie
Yaw Gallery

Iwata, Kiyomi
Snyderman-Works Galleries

J

Jackson, Daniel
Moderne Gallery

Jacobi, Ritzi
Snyderman-Works Galleries

Jacobs, Ferne
Nancy Margolis Gallery

Janich, Hilde
Charon Kransen Arts

Jank, Michael
Jewelers' Werk Galerie

Jay, Alina
Charon Kransen Arts

Jendis, Stephanie
Sienna Gallery

Jocz, Dan
Mobilia Gallery

Johanson, Olle
Yaw Gallery

Johanson, Rosita
Mobilia Gallery

Johansson, Karin
Charon Kransen Arts

John, Svenja
Jewelers' Werk Galerie

Johnston, Randy
Lacoste Gallery

Jolley, Richard
Leo Kaplan Modern

Jónsdóttir, Kristín
browngrotta arts

Jordan, John
del Mano Gallery

Joy, Christine
browngrotta arts

Juenger, Ike
Charon Kransen Arts

Jünger, Hermann
Helen Drutt: Philadelphia
Jewelers' Werk Galerie

Kakizaki, Hitoshi
Thomas R. Riley Galleries

Kallenberger, Kreg
Leo Kaplan Modern

Kamoda, Shoji
Joan B. Mirviss, Ltd.

Kaneko, Jun
Brendan Walter Gallery

Kaneshige, Kosuke
Dai Ichi Arts, Ltd.

Kaneta, Masanao
Joan B. Mirviss, Ltd.

Kang, Dallae
Snyderman-Works Galleries

Kang, Yeonmi
Charon Kransen Arts

Karnes, Karen
Moderne Gallery

Katoh, Tsubusa
Dai Ichi Arts, Ltd.

Katsushiro, Soho
Tai Gallery/Textile Arts

Kaufman, Glen
browngrotta arts

Kaufmann, Martin
Charon Kransen Arts
Galerie Tactus
Jewelers' Werk Galerie

Kaufmann, Ruth
browngrotta arts

Kaufmann, Ulla
Charon Kransen Arts
Galerie Tactus
Jewelers' Werk Galerie

Kawano, Shoko
Tai Gallery/Textile Arts

Kawase, Shinobu
Joan B. Mirviss, Ltd.

Kawashima, Shigeo
Tai Gallery/Textile Arts

Kawata, Tamiko
browngrotta arts

Kegley, Charles
Finer Things Gallery

Kegley, Tami
Finer Things Gallery

Kent, Ron
del Mano Gallery

Kerman, Janis
Option Art

Kiener, Connie
Lacoste Gallery

Kim, Kyung Shin
The David Collection

Kindelmann, Heide
The David Collection

King, Betsy
Helen Drutt: Philadelphia

Kirkpatrick, Joey
Brendan Walter Gallery

Kitamura, Junko
Joan B. Mirviss, Ltd.

Klancic, Anda
browngrotta arts

Knapp, Stephen
Walker Fine Art

Knauss, Lewis
browngrotta arts

Knobel, Esther
Sienna Gallery

Knowles, Sabrina
R. Duane Reed

Kobayashi, Mazakazu
browngrotta arts

Kobayashi, Naomi
browngrotta arts

Koch, Gabriele
Clay

Koenigsberg, Nancy
browngrotta arts

Kohyama, Yasuhisa
browngrotta arts

Koike, Shoko
Joan B. Mirviss, Ltd.

Koinuma, Michio
Joan B. Mirviss, Ltd.

Kolesnikova, Irina
browngrotta arts

Kondo, Takahiro
Joan B. Mirviss, Ltd.

Koopman, Rena
Mobilia Gallery

Korowitz-Coutu, Laurie
UrbanGlass New York
 Contemporary Glass Center

Kosonen, Markku
browngrotta arts

Kraen, Anette
Mobilia Gallery

Kraft, Jim
Gallery Materia

Krakowski, Yael
Charon Kransen Arts

Kranitzky, Robin
Helen Drutt: Philadelphia

Krauss, Alyssa Dee
Sienna Gallery

Kreuder, Loni
Modus Gallery

Krinos, Daphne
Mobilia Gallery

Krupenia, Deborah
Charon Kransen Arts

Kubota, Shigeo
Lea Sneider

Kuhn, Jon
Marx-Saunders Gallery, Ltd.

Kulicke, Fredricka
Aaron Faber Gallery

Kumai, Kyoko
browngrotta arts

Künzli, Otto
Jewelers' Werk Galerie

Kuo, Yih-Wen
Loveed Fine Arts

Kuramoto, Yoko
Chappell Gallery

Kurokawa, Okinari
Mobilia Gallery

Kusama, Tetsuo
Lea Sneider

Kusumoto, Mariko
Mobilia Gallery

L

Laky, Gyöngy
browngrotta arts

Lamar, Stoney
del Mano Gallery

Lamb, Andrew
Mobilia Gallery

LaMonte, Karen
Heller Gallery

Lane, Ned
Yaw Gallery

LaPointe, Michèle
Option Art

Larocque, Jean-Pierre
Garth Clark Gallery

Larssen, Ingrid
The David Collection

Latven, Bud
del Mano Gallery

Lee, Chunghie
Lea Sneider

Lee, Dongchun
Charon Kransen Arts

Lee, Ed Bing
Snyderman-Works Galleries

Lee, Ke-sook
Snyderman-Works Galleries

Lee, Seung-Hea
Jewelers' Werk Galerie
Sienna Gallery
Yaw Gallery

Leedy, Jim
WEISSPOLLACK

Legrand, Jean-Claude
Galerie b15–Renate Wunderle

Lemon, Christina A.
Yaw Gallery

Leuthold, Marc
Loveed Fine Arts

Levenson, Silvia
Caterina Tognon Arte
 Contemporanea

Lewis, John
Leo Kaplan Modern

Li, Jiansheng
Nancy Margolis Gallery

Libenský, Stanislav
Barry Friedman Ltd.
Brendan Walter Gallery
Donna Schneier Fine Arts

Lieglein, Walli
Jewelers' Werk Galerie

Liez, Gladys
Galerie Ateliers
 d'Art de France

Lillie, Jacqueline
Sienna Gallery

Lindqvist, Inge
browngrotta arts

Lislerud, Ole
Loveed Fine Arts

Littleton, Harvey K.
Donna Schneier Fine Arts
Maurine Littleton Gallery

Littleton, John
Maurine Littleton Gallery

Ljones, Åse
browngrotta arts

Loeser, Thomas
Leo Kaplan Modern

Lønning, Kari
browngrotta arts

Løvaas, Astrid
browngrotta arts

Lovendahl, Nancy
Loveed Fine Arts

Lozier, Deborah
Yaw Gallery

Lucero, Michael
Donna Schneier Fine Arts

Lühtje, Christa
Jewelers' Werk Galerie

Lunderskov, Anders
Galerie Tactus

Lyon, Lucy
Thomas R. Riley Galleries

Mace, Flora
Brendan Walter Gallery

Machata, Peter
Charon Kransen Arts

MacNeil, Linda
Leo Kaplan Modern

MacNutt, Dawn
browngrotta arts

Madden, Thomas
Yaw Gallery

Madola
Galerie b15–Renate Wunderle

Maierhofer, Fritz
Mobilia Gallery

Maioral, Enric
Aaron Faber Gallery

Makigawa, Carlier
Helen Drutt: Philadelphia

Makins, Jim
Donna Schneier Fine Arts

Malinowski, Ruth
browngrotta arts

Maloof, Sam
Moderne Gallery

Manz, Bodil
Garth Clark Gallery

Marchetti, Stefano
Charon Kransen Arts

Marco del Pont, Celia
Artempresa Gallery

Marder, Donna Rhae
Mobilia Gallery

Marioni, Dante
Brendan Walter Gallery
Holsten Galleries

Marioni, Paul
Brendan Walter Gallery

Marquis, Richard
Brendan Walter Gallery
Caterina Tognon Arte
 Contemporanea

Marsland, Sally
Jewelers' Werk Galerie

Martinazzi, Bruno
Helen Drutt: Philadelphia

Maruyama, Tomomi
Mobilia Gallery

Marx, Falko
Helen Drutt: Philadelphia

Mason, John
Franklin Parrasch Gallery

Matsuda, Yuriko
Dai Ichi Arts, Ltd.

Matsushima, Iwao
Mostly Glass Gallery

Mattar, Wilheim Tasso
The David Collection

Mattes, Danae
Galerie b15–Renate Wunderle

Matthias, Christine
Charon Kransen Arts

Mattia, Alphonse
Mobilia Gallery
Moderne Gallery

May, Debra
Gallery Materia

Mayeri, Beverly
Franklin Parrasch Gallery

Mazzoni, Ana
Artempresa Gallery

McClellan, Duncan
Thomas R. Riley Galleries

McDevitt, Elisabeth
Charon Kransen Arts
Mobilia Gallery

McMullen, Richard
Aaron Faber Gallery

McQueen, John
Mobilia Gallery

McVey, Leza
Moderne Gallery

Medel, Rebecca
browngrotta arts

Merkel-Hess, Mary
browngrotta arts

Mestre, Enrique
Galerie b15–Renate Wunderle

Metcalf, Bruce
Charon Kransen Arts
Helen Drutt: Philadelphia

Michaels, Guy
Finer Things Gallery

Michel, Nancy
Mobilia Gallery

Micheluzzi, Massimo
Barry Friedman Ltd.

Miguel
Charon Kransen Arts

Milette, Richard
Option Art

Minegishi, Seiko
Joan B. Mirviss, Ltd.

Minegishi, Yutaka
Jewelers' Werk Galerie

Miro, Darcy
Jewelers' Werk Galerie

Mitchel, Craig
Clay

Mitchell, Valerie
Jewelers' Werk Galerie

Mitsushima, Kazuko
Mobilia Gallery

Miyamura, Hideaki
WEISSPOLLACK

Miyashita, Zenji
Joan B. Mirviss, Ltd.

Mizuno, Keisuke
Lacoste Gallery

Möhwald, Gertraud
Galerie b15–Renate Wunderle

Monden, Yuichi
Tai Gallery/Textile Arts

Monzo, Marc
Charon Kransen Arts

Mori, Togaku
Joan B. Mirviss, Ltd.

Morigami, Jin
Tai Gallery/Textile Arts

Morino, Taimei
Joan B. Mirviss, Ltd.

Morris, William
Barry Friedman Ltd.
Brendan Walter Gallery
Donna Schneier Fine Arts

Morrison, Merrill
Mobilia Gallery

Moulthrop, Ed
Moderne Gallery

Moulthrop, Matt
Gallery Materia

Moulthrop, Philip
del Mano Gallery
Gallery Materia

Mourosso
Modus Gallery

Mulford, Judy
browngrotta arts

Munsteiner, Bernd
Aaron Faber Gallery

Munsteiner, Jutta
Aaron Faber Gallery

Munsteiner, Tom
Aaron Faber Gallery

Murphy, Kathie
The David Collection

Murray, David
Chappell Gallery

Muzylowski-Allen, Shelley
Thomas R. Riley Galleries

Myers, Joel Philip
Marx-Saunders Gallery, Ltd.

Myers, Rebecca
Brendan Walter Gallery

Nagakura, Kenichi
Tai Gallery/Textile Arts

Nagle, Ron
Garth Clark Gallery

Nagy, Sylvia
Loveed Fine Arts

Nakamura, Naoka
Charon Kransen Arts

Nakamura, Takuo
Joan B. Mirviss, Ltd.

Nakashima, George
Moderne Gallery

Nakashima, Harumi
Dai Ichi Arts, Ltd.

Nakashima, Mira
Moderne Gallery

Nancey, Christophe
Galerie Ateliers
 d'Art de France

Negre, Suzanne Otwell
The David Collection

Newman, Paula Judith
Yaw Gallery

Niehues, Leon
browngrotta arts

Nio, Keiji
browngrotta arts

Notkin, Richard
Garth Clark Gallery

Nunan, Shona
Artempresa Gallery

O'Casey, Breon
Helen Drutt: Philadelphia

O'Connor, Harold
Mobilia Gallery

Ogura, Ritsuko
Helen Drutt: Philadelphia
Mobilia Gallery

Ohira, Yoichi
Barry Friedman Ltd.

Oliver, Gilda
Loveed Fine Arts

Onofrio, Judy
Helen Drutt: Philadelphia

Ortiz, Virgil
Garth Clark Gallery

Osolnik, Rude
Moderne Gallery

Ott, Helge
The David Collection

Overstreet, Kim
Helen Drutt: Philadelphia

Owen, Mary Ann Spavins
Yaw Gallery

Paganin, Barbara
Charon Kransen Arts

Pagliaro, John
Garth Clark Gallery

Paley, Albert
Brendan Walter Gallery
Donna Schneier Fine Arts

Papesch, Gundula
Charon Kransen Arts

Parcher, Joan
Mobilia Gallery

Pardon, Tod
Aaron Faber Gallery

Paredes, Miel
Yaw Gallery

Parker-Eaton, Sarah
del Mano Gallery

Parmentier, Silvia
Artempresa Gallery

Parsons, Greg
browngrotta arts

Pasquer, Nadia
Galerie Ateliers
 d'Art de France

Paul, Adelaide
Garth Clark Gallery

Paulsen, Stephen Mark
del Mano Gallery

Paust, Karen
Mobilia Gallery

Pavan, Francesco
Helen Drutt: Philadelphia

Peiser, Mark
Marx-Saunders Gallery, Ltd.

Perez Guaita, Gabriela
Artempresa Gallery

Perez, Jesus Curia
Ann Nathan Gallery

Perkins, Sarah
Mobilia Gallery

Peters, Ruudt
Jewelers' Werk Galerie

Peterson, Michael
del Mano Gallery

Petrovic, Marc
Thomas R. Riley Galleries

Petter, Gugger
Mobilia Gallery

Pharis, Mark
Lacoste Gallery

Pheulpin, Simone
browngrotta arts

Phillips, Maria
The David Collection

Pho, Binh
del Mano Gallery

Pierce, Shari
Jeweler's Werk Galerie

Pimental, Alexandra
The David Collection

Planteydt, Annelies
Charon Kransen Arts

Podgoretz, Larissa
Aaron Faber Gallery
del Mano Gallery

Pohlman, Jenny
R. Duane Reed

Poissant, Gilbert
Option Art

Pollack, Junco Sato
Lea Sneider

Poller, Leah
Artempresa Gallery

Pontoppidan, Karen
Jewelers' Werk Galerie

Portanier, Gilbert
Galerie b15–Renate Wunderle

Powell, Stephen Rolfe
Holsten Galleries

Pragnell, Valerie
browngrotta arts

Prestini, James
Moderne Gallery

Preston, Mary
Jewelers' Werk Galerie
Mobilia Gallery

Price, Ken
Donna Schneier Fine Arts
Franklin Parrasch Gallery
Garth Clark Gallery

Priest, Frances
Clay

Priest, Linda Kindler
Aaron Faber Gallery

Prühl, Dorothea
Jewelers' Werk Galerie

Puig Cuyas, Ramon
Helen Drutt: Philadelphia

Quadri, Giovanna
Mobilia Gallery

Quigley, Robin
Mobilia Gallery

Rachins, Gerri
Mobilia Gallery

Rack, Anette
Mobilia Gallery

Rady, Elsa
Franklin Parrasch Gallery

Ramshaw, OBE RDI, Wendy
Mobilia Gallery

Rana, Mah
Jewelers' Werk Galerie

Randal, Seth
Thomas R. Riley Galleries

Rankin, Susan
Galerie Elena Lee

Rath, Tina
Sienna Gallery

Rawdin, Kim
Mobilia Gallery

Rea, Mel
Thomas R. Riley Galleries

Reed, Todd
Charon Kransen Arts
Mobilia Gallery

Reekie, David
Thomas R. Riley Galleries

Regan, David
Garth Clark Gallery

Reichert, Sabine
The David Collection

Reid, Colin
Maurine Littleton Gallery

Reimers-Crystol, Rebecca
Yaw Gallery

Reynolds, Nancy Sansom
Gallery Materia

Rezac, Suzan
Mobilia Gallery

Rhoads, Kait
Chappell Gallery

Richmond, Ross
R. Duane Reed

Richmond, Vaughn
del Mano Gallery

Rigan, Otto
Gallery Materia

Riis, Jon Eric
Snyderman-Works Galleries

Ritter, Richard
Marx-Saunders Gallery, Ltd.

Rivera, Alexandra
Jewelers' Werk Galerie

Roberts, David
Clay

Robertson, Kaz
Mobilia Gallery

Roessler, Joyce
Chappell Gallery

Roher-Casellas, Carme
Mobilia Gallery

Rosanjin, Kitaôji
Joan B. Mirviss, Ltd.
Franklin Parrasch Gallery

Rose, Jim
Ann Nathan Gallery

Rose, John
Gallery Materia

Rosenfeld, Erica
UrbanGlass New York
 Contemporary Glass Center

Rosenmiller, Betsy
Lacoste Gallery

Rosin, Mariagrazia
Caterina Tognon Arte
 Contemporanea

Rosol, Martin
Holsten Galleries

Rossano, Joseph
Thomas R. Riley Galleries

Rossbach, Ed
browngrotta arts
Mobilia Gallery

Roth, David
Moderne Gallery

Rothmann, Gerd
Helen Drutt: Philadelphia

Rothstein, Scott
browngrotta arts
Mobilia Gallery

Rousseau-Vermette, Mariette
browngrotta arts

Rowan, Tim
Lacoste Gallery

Rügge, Caroline
Mobilia Gallery

Russell-Pool, Kari
Thomas R. Riley Galleries

Russmeyer, Axel
Mobilia Gallery

Ruzsa, Alison
Mostly Glass Gallery

Ryan, Jackie
Charon Kransen Arts

Sachs, Debra
browngrotta arts

Safire, Helene
UrbanGlass New York
 Contemporary Glass Center

Saito, Kayo
The David Collection

Saito, Yuka
Mobilia Gallery

Sakiyama, Takayuki
Joan B. Mirviss, Ltd.

Sakwa, Hap
Moderne Gallery

Salomon, Alain
Modus Gallery

Samplonius, David
Option Art

Sanford, Claire
Yaw Gallery

Sano, Takeshi
Chappell Gallery

Sano, Youko
Chappell Gallery

Sarneel, Lucy
Charon Kransen Arts

Schaefer, Fabrice
Charon Kransen Arts

Scharff, Allan
Galerie Tactus

Scherr, Sydney
Aaron Faber Gallery

Schick, Marjorie
Mobilia Gallery

Schippel, Dorothea
Jewelers' Werk Galerie

Schlatter, Sylvia
Charon Kransen Arts

Schleeh, Colin
Option Art

Schmid, Renate
Charon Kransen Arts

Schmitz, Claude
Charon Kransen Arts

Schneeweiss, Margrit
Jewelers' Werk Galerie

Schobinger, Bernard
Helen Drutt: Philadelphia

Schocken, Deganit
Helen Drutt: Philadelphia

Schunke, Michael
Brendan Walter Gallery

Schutz, Biba
Charon Kransen Arts

Schwaiger, Berthold
The David Collection

Scoon, Thomas
Marx-Saunders Gallery, Ltd.

Scott, Gale
Chappell Gallery

Scott, Joyce J.
Mobilia Gallery
Snyderman-Works Galleries

Seegers, Larry
The David Collection

Seeman, Bonnie
Lacoste Gallery

Seid, Carrie
Gallery Materia

Seide, Paul
Leo Kaplan Modern

Seidenath, Barbara
Jewelers' Werk Galerie
Sienna Gallery

Sekiji, Toshio
browngrotta arts

Sekijima, Hisako
browngrotta arts

Sekimachi, Kay
browngrotta arts

Sells, Brad
Finer Things Gallery

Selva, Margarita
Artempresa Gallery

Selwood, Sarah Jane
Clay

Semecká, Lada
Chappell Gallery

Sengel, David
del Mano Gallery

Serino, Naoko
Lea Sneider

Shabahang, Bahram
Orley Shabahang

Shaffer, Mary
Donna Schneier Fine Arts

Shapiro, Mark
Lacoste Gallery

Shaw, Richard
Mobilia Gallery

Shaw-Sutton, Carol
browngrotta arts

Sherman, Sondra
Sienna Gallery

Shimazu, Esther
John Natsoulas Gallery

Shin, Sang Ho
Lea Sneider

Shindo, Hiroyuki
browngrotta arts

Shioya, Naomi
Chappell Gallery

Shirk, Helen
Helen Drutt: Philadelphia

Shuler, Michael
del Mano Gallery

Šibor, Jiří
Jewelers' Werk Galerie

Sieber Fuchs, Verena
Charon Kransen Arts

Siemund, Vera
Jewelers' Werk Galerie

Siesbye, Alev Ebüzziya
Garth Clark Gallery

Simon, Marjorie
Charon Kransen Arts

Simpson, Tommy
Leo Kaplan Modern

Sisson, Karyl
browngrotta arts

Skubic, Peter
Helen Drutt: Philadelphia

Slagle, Nancy
Yaw Gallery

Slepian, Marian
Aaron Faber Gallery

Sloan, Susan Kasson
Aaron Faber Gallery

Smelvær, Britt
browngrotta arts

Smith, Christina
Mobilia Gallery

Smith, Fraser
del Mano Gallery

Smith, Hassel
John Natsoulas Gallery

So, Jin-Sook
browngrotta arts
Charon Kransen Arts
Lea Sneider

Sonobe, Etsuko
Mobilia Gallery

Sørenson, Grethe
browngrotta arts

Spano, Elena
Charon Kransen Arts

Speaker, Michael
Ann Nathan Gallery

Speckner, Bettina
Jewelers' Werk Galerie
Sienna Gallery

Spira, Rupert
Clay

Staffel, Rudolf
Helen Drutt: Philadelphia

Stair, Julian
Clay

Stanger, Jay
Leo Kaplan Modern

Stankard, Paul
Marx-Saunders Gallery, Ltd.

Statom, Therman
Maurine Littleton Gallery

Stebler, Claudia
Charon Kransen Arts

Sterling, Lisabeth
Marx-Saunders Gallery, Ltd.

Stiansen, Kari
browngrotta arts

Stocksdale, Bob
Moderne Gallery

Štohanzl, Jan
Chappell Gallery

Stone, Judy
Aaron Faber Gallery

Striffler, Dorothee
Charon Kransen Arts

Strokowsky, Cathy
Galerie Elena Lee

Stutman, Barbara
Charon Kransen Arts

Sugita, Jozan
Tai Gallery/Textile Arts

Suh, Byung-Joo
Snyderman-Works Galleries

Suh, Hye-Young
Charon Kransen Arts

Suh, Mary
Loveed Fine Arts

Suydam, Didi
Jewelers' Werk Galerie

Suzuki, Goro
Dai Ichi Arts, Ltd.

Suzuki, Junko
Lea Sneider

Svensson, Tore
Charon Kransen Arts
Helen Drutt: Philadelphia
Jewelers' Werk Galerie

Syvanoja, Janna
Charon Kransen Arts

T

Tagliapietra, Lino
Heller Gallery

Takaezu, Toshiko
Moderne Gallery

Takamiya, Noriko
browngrotta arts

Tanaka, Chiyoko
browngrotta arts

Tanaka, Hideho
browngrotta arts
Lea Sneider

Tanaka, Kyokusho
Tai Gallery/Textile Arts

Tanigaki, Ema
del Mano Gallery

Tanikawa, Tsuroko
browngrotta arts

Tate, Blair
browngrotta arts

Tawney, Lenore
browngrotta arts

Taylor, Michael
Leo Kaplan Modern

Tchalenko, Janice
Clay

Thakker, Salima
Charon Kransen Arts

Thiewes, Rachelle
Jewelers' Werk Galerie

Thomas, Diana
Lacoste Gallery

Thompford, Pamela Morris
Yaw Gallery

Thompson, Cappy
Leo Kaplan Modern

Thompson, Joanne
Mobilia Gallery

Threadgill, Linda
Mobilia Gallery

Throop, Thomas
WEISSPOLLACK

Timar, Tibor
Ann Nathan Gallery

Tingleff, Marit
Nancy Margolis Gallery

Toland, Tip
Nancy Margolis Gallery

Tolosa, Maria Alejandra
Artempresa Gallery

Tolvanen, Terhi
Charon Kransen Arts

Tomasi, Henriette
Charon Kransen Arts

Tomasi, Martin
Charon Kransen Arts

Tomita, Jun
browngrotta arts

Tompkins, Merrily
Helen Drutt: Philadelphia

Toops, Cynthia
Mobilia Gallery

Torii, Ippo
Tai Gallery/Textile Arts

Toso, Gianni
Leo Kaplan Modern

Toubes, Xavier
Loveed Fine Arts

Trask, Jennifer
Mobilia Gallery

Trekel, Silke
Charon Kransen Arts

Trucchi, Yves
Galerie Daniel Guidat

Tsukada, Keizo
Finer Things Gallery

Tuberty, Tom
Gallery Materia

Turner, Robert
Helen Drutt: Philadelphia

Ungvarsky, Melanie
UrbanGlass New York
 Contemporary Glass Center

Uravitch, Andrea
Mobilia Gallery

Urbain, John A.
WEISSPOLLACK

Urbschat, Erik
Charon Kransen Arts

Urino, Kyoko
The David Collection
Mobilia Gallery

Urruty, Joël
Finer Things Gallery

Valkoua, Rouska
Loveed Fine Arts

Vallee, Nad
Galerie Daniel Guidat

Valoma, Deborah
browngrotta arts

van Aswegen, Johan
Sienna Gallery

Van Cline, Mary
Leo Kaplan Modern

van der Leest, Felieke
Charon Kransen Arts

Van Nostrand, Lydia
Yaw Gallery

VandenBerge, Peter
John Natsoulas Gallery

Vermandere, Peter
Charon Kransen Arts

Vermette, Claude
browngrotta arts

Vesery, Jacques
del Mano Gallery

Viennet, Christine
Lacoste Gallery

Vigeland, Tone
Helen Drutt: Philadelphia

Vikman, Ulla-Maija
browngrotta arts

Viot, Jean-Pierre
Galerie b15–Renate Wunderle

Visintin, Graziano
Mobilia Gallery

Visschers, Robean
Charon Kransen Arts

Vizner, František
Barry Friedman, w Ltd.
Donna Schneier Fine Arts

Vogel, Kate
Maurine Littleton Gallery

von Rimscha, Agnes
Jewelers' Werk Galerie

Voulkos, Peter
Franklin Parrasch Gallery
Moderne Gallery

Wagle, Kristen
browngrotta arts

Wagner, Karin
Charon Kransen Arts

Wahl, Wendy
browngrotta arts

Walch, Anuschka
Jewelers' Werk Galerie

Walentynowicz, Janusz
Marx-Saunders Gallery, Ltd.

Walker, Jason
Gallery Materia

Walker, Lisa
Jewelers' Werk Galerie

Walter, Barbara
Mobilia Gallery

Walter, Brendan
Brendan Walter Gallery

Waltz, Silvia
The David Collection

Wang, Kiwon
Snyderman-Works Galleries

Warashina, Patti
Loveed Fine Arts

Warner, Deborah
Snyderman-Works Galleries

Washio-Schecterson, Misa
Mobilia Gallery

Watkins, Alexandra
Mobilia Gallery

Webb, Carol
Yaw Gallery

Webster, Maryann
Lacoste Gallery

Wegman, Kathy
Snyderman-Works Galleries

Wegman, Tom
Snyderman-Works Galleries

Weinberg, Steven
Leo Kaplan Modern

Weissflog, Hans
del Mano Gallery

Wesel, Claude
Mobilia Gallery

West, Margaret
Helen Drutt: Philadelphia

Westphal, Katherine
browngrotta arts
Mobilia Gallery

Whitney, Ginny
Aaron Faber Gallery
Jewelers' Werk Galerie

Wieske, Ellen
Mobilia Gallery

Willenbrink-Johnsen, Karen
Thomas R. Riley Galleries

Winokur, Paula
Helen Drutt: Philadelphia

Winokur, Robert
Helen Drutt: Philadelphia

Wippermann, Andrea
Jewelers' Werk Galerie

Wise, Jeff
Aaron Faber Gallery

Wise, Susan
Aaron Faber Gallery

Wolfe, Rusty
Finer Things Gallery

Woo, Jin-Soon
Charon Kransen Arts

Wood, Beatrice
Donna Schneier Fine Arts
Garth Clark Gallery

Wood, Joe
Mobilia Gallery

Wood, Susan Elizabeth
Yaw Gallery

Woodman, Betty
Donna Schneier Fine Arts
Franklin Parrasch Gallery

Worden, Nancy
Helen Drutt: Philadelphia

Xiaoping, Luo
Helen Drutt: Philadelphia

Yamada, Mizuko
Mobilia Gallery

Yamaguchi, Noriko
Snyderman-Works Galleries

Yamaguchi, Ryuun
Tai Gallery/Textile Arts

Yamamoto, Yoshiko
Mobilia Gallery
Yaw Gallery

Yamanaka, Kazuko
Lea Sneider

Yamano, Hiroshi
Thomas R. Riley Galleries

Yasuda, Takeshi
Clay

Yeung, Alex
Option Art

Yokouchi, Sayumi
Yaw Gallery

Yonezawa, Jiro
browngrotta arts

Yoshida, Masako
browngrotta arts

Yoshikawa, Masamichi
Galerie b15–Renate Wunderle

Youn, Soonran
Snyderman-Works Galleries

Yuh, Sun Koo
Helen Drutt: Philadelphia

Zanella, Annamaria
Charon Kransen Arts

Zhitneva, Sasha
UrbanGlass New York
 Contemporary Glass Center

Zimmerman, Arnold
Nancy Margolis Gallery

Zimmermann, Erich
Charon Kransen Arts

Zobel, Michael
Aaron Faber Gallery

Zoritchak, Yan
Galerie Daniel Guidat

Zuber, Czeslaw
Galerie Daniel Guidat

Zucca, Ed
Leo Kaplan Modern

Zynsky, Toots
Barry Friedman Ltd.

John Dickinson TABLE LAMP, MODEL NO. 101-C, *CIRCA* 1976
HEIGHT: 29 IN. 73.3 CM ESTIMATE: $5,000-7,000